A History of
BOCA RATON

A History of
BOCA RATON

Sally J. Ling

Charleston ⫙ London

History
PRESS

Published by The History Press
Charleston, SC 29403
www.historypress.net

Front cover image courtesy of the Boca Raton Resort & Club.
Back cover: The Boca Raton Historical Society restored Old Town Hall, where they now have their offices. Their Capital Fund Drive began in November 1982, and ended in July 1984, raising $508,000. *Photo courtesy of the Boca Raton Historical Society.*

First published 2007

Manufactured in the United Kingdom

ISBN 978.1.59629.135.5

Library of Congress Cataloging-in-Publication Data

Ling, Sally J.
 A history of Boca Raton, Florida / Sally J. Ling.
 p. cm.
 Includes bibliographical references and index.
 ISBN-13: 978-1-59629-135-5 (alk. paper)
 1. Boca Raton (Fla.)--History. 2. Boca Raton (Fla.)--History--Pictorial
works. I. Title.
 F319.B6L56 2007
 975.9'32--dc22
2006039550

CONTENTS

ACKNOWLEDGEMENTS

I t is a pleasure to thank publicly those who assisted in the publication of this book. They are Susan Gillis, archivist of the Boca Raton Historical Society, for her invaluable expertise and assistance with the photos; the Boca Raton Historical Society for access to their photographs, documents and personal histories that made the story come alive; my sister, Pat Keeley, for editing; Pat Jakubek, whose personal research and contacts proved invaluable; my family and friends who gave me encouragement; and a special thanks to Peg McCall, Boca Raton's first archivist, who assisted in the final review process.

INTRODUCTION

If Captain Thomas Moore Rickards—Boca Raton's first pioneer—were alive, I believe his eyes would widen to platter-like proportions to see Boca Raton today. Where tall pines once reached to the heavens, towering condominiums now scratch the clouds. Where sandy trails lazily meandered through palmettos and scrub oak, six-lane asphalt highways provide contemporary travelers a straight and rapid shot to their destinations. And where fields of pineapples, tomatoes and beans previously grew to support farmers who occupied the fertile land, multi-story office buildings, upscale residential homes and plush golf courses stretch to the horizon.

If Rickards were alive, I believe he would be "find me a chair" amazed to realize that the primitive land that once bore the name Boca de Ratones would, in time, turn from its agricultural base to become a high-tech community. Hardships of daily living would be transformed into a level of comfort no previous residents had known.

Yes, I believe Rickards would be amazed, but I also believe he would be proud—proud that his efforts and vision for Boca Raton spawned a vital Greater Boca Raton community of over 195,000 residents where businesses thrive and residents of differing cultures live in harmony.

In the following pages, I hope to bring to life the reality of the struggle of the community, truly a labor of love, to transform Boca Raton from its humble beginning in 1895 into a success story of the twenty-first century.

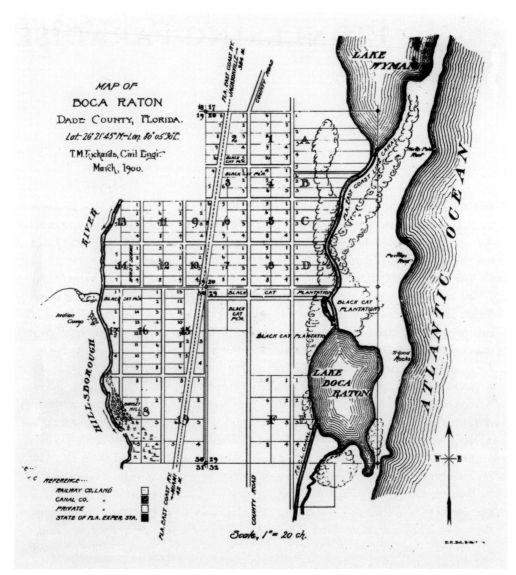

Penned by Captain Thomas Moore Rickards, this map from 1900 shows the first survey of Boca Raton. *Photo courtesy of the Boca Raton Historical Society.*

PIONEERING PARADISE

Captain Thomas Moore Rickards scanned the clearing before him. Tucked back in the thick pine forest, a stone circle, its rocks smudged with black soot, outlined a fire pit. Several pine logs with their rough bark still intact lined the campfire for seating. It was obvious that others making their way south to Miami had camped at the clearing before him.

"We'll stop here," said Rickards to his crew of five, which included his brother and C. W. Blaine, a Negro—a most unusual sight in the company of an all-white surveying team. Blaine pulled back steadily on the leather reins. Bringing the wagon and team of horses to a stop, he set the brake. The horses snorted softly. White froth clung to the sides of their mouths as they gnawed at their bits. It had been a long, hot day and everyone, including the horses, was tired. Even the crew's calico feline companion was ready for a rest.

After dinner, the men sat around the crackling fire and planned their next day. Smoke from tobacco-filled pipes curled upward toward the long-needled pine boughs and beyond, where it mixed with the brilliant stars that hung like sparkling diamonds in the dark cloudless sky. Fireflies darted in and out of the trees and brush that surrounded the makeshift camp. The soft "w-h-o-o-o" of a great horned owl floated on a light breeze, and large black pupils of a lone tawny-colored Florida panther eyed the strangers curiously from a respectable distance.

Rickards filled his lungs with the woodsy scent of the forest. An Ohio-born surveyor and civil engineer, he and his crew had worked their way down the Florida peninsula surveying parcels of land for the state. With each workday, he grew more fond of southern Florida and his trek through the pristine land of sand, scrub oak and slash pine called Boca Ratones was tilting that fondness into thoughts of settling down there.

It could have been the devastating freezes that destroyed his citrus groves in Candler, in the central part of Florida where he was then living, or simply his yearning to move farther south. Whatever it was, the scale finally tilted decidedly and the uninhabited land called Boca Ratones soon became his home.

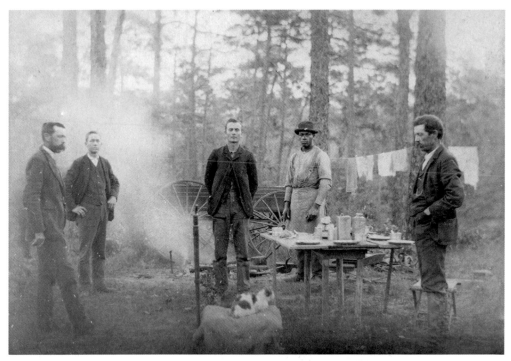

Captain Rickards (far right) and his surveying team, including his brother (far left) and C.W. Blaine (second from right), arrive in Boca Raton in 1895. *Photo courtesy of the Boca Raton Historical Society.*

PIRATES AND DOUBLOONS

Long before Rickards planted his feet on Boca Ratones soil, it was rumored that pirates in their Spanish galleons sailed its unspoiled shores. Legend has it these treacherous marauders used the Boca Raton inlet to elude capture between merchant raids. Stories also tell of buried treasure in sand dunes. Even the ghost of Blackbeard, one of the most notorious pirates, is said to have taken the form of a seagull to guard the gold doubloons buried under a large gumbo-limbo tree.

Were these stories fact or fiction? Harriette Gates, wife of early pioneer H.D. Gates who arrived in 1914, penned this anecdote in her memoirs that was reprinted in the August 10, 1951 edition of the *Pelican*, Boca Raton's hometown paper:

1914: Captain Jim Lynch

Destination: Boca Raton. No one ever knew from where, out of the unknown, he came. Quite suddenly, he was encamped by a fresh water spring below the inlet in an old houseboat, later to move to a shack on the high ridge just above the inlet. A silent, reticent man, courteous but cautious. He once showed Mr. Gates an old parchment map on which was marked the exact location where pirate loot of old Spanish Galleons was buried, according to his claim. He had remarked that he once owned a fishing skiff and fished off

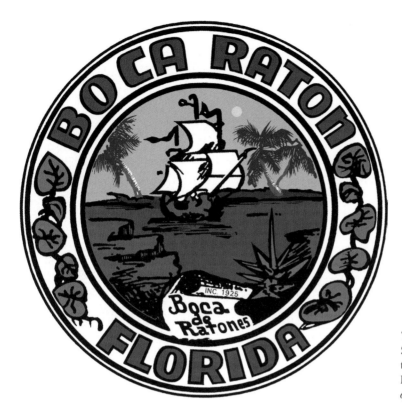

The Boca Raton City Seal depicts elements that represent Boca Raton. *Photo courtesy of City of Boca Raton.*

the Massachusetts coast…Captain Jim [was] like a mild pirate, he received no mail, and no close associates though he often brought fish to the few families in town and hesitantly accepted baked food from the housewives, but discouraged the faintest signs of familiarity. When he became ill in 1919, he was taken to the Pioneer Hotel in Deerfield to be cared for, and passed away in a short time. The map, which might have been a clue, was never found, for he left no personal belongings.

Those were the years of the outlaws in Florida—when the vast Everglades was the Saragossa [sic] Sea for all who wished to escape the law and live in loneliness and silence with their guns and their conscience. Why was Captain Jim hiding out? Was it sorrow or crime that kept him a recluse? Even Boca Raton was refuge in those days. Several strangers came, stayed a short time, and vanished. We asked no questions.

When a road crew building Ocean Boulevard (A1A) in 1920 found a few doubloons, credibility was given to stories of buried treasure and a number of treasure hunts ensued. While no large stash of gold was ever found, tales persisted of a ship foundering off the coast, its anchor stuck in a reef. It purportedly contained a load of silver bars.

Because there was no Boca Raton Inlet at the time galleons were rumored to have entered it (see Rickards's map) and Lake Boca Raton was only a very shallow marsh, it is highly unlikely these legends are true. And, if any of it is true, it is more likely that the Boca de Ratones referred to along with the Spanish galleons was located in the Miami area.

However, in honor of the city's rumored past, in 1951 Jim Vandermale designed a city seal that included the rendering of a galleon. Although the seal has been used since 1978, the city did not officially adopt it until 1991.

George Brown, deputy city manager, explained the symbols on the seal:

> *The elements appear to have been chosen for the following reasons:*
> *The morning sun over the barrier island indicates the climate that makes Boca Raton special and makes note of lakes on what is now the Intracoastal. The Spanish galleon suggests the explorers and buccaneers who sailed off the shores of Florida in the 1500s...*
> *The Spanish name "Boca de Ratones" is the original name of the City.*

Indian Inhabitants

Prior to the rumored pirates landing on its shores or Rickards's wagon making camp at the clearing, the fertile land of Boca Ratones was home to the Tequesta tribe. As the first inhabitants, they lived peaceably in communities near the ocean until slave traders captured them in the early 1700s and took them to Charleston, South Carolina, where they were sold as slaves in the West Indies.

In 1763 England took control of Florida, sending the conquering Spanish back across the Atlantic. Upon departing, the Spaniards took the last aboriginal Indians with them. Except for a few scattered families, Florida was cleared of its original inhabitants.

Twenty years later, England ceded Florida back to Spain, and in 1821 Florida became a U.S. possession. From 1825 to 1925, a collection of Indian tribes known as the Seminole moved into Florida. A few made hunting trips into the Boca Raton area, establishing camps and planting gardens. Then came the Seminole Wars.

In the First Seminole War, the Seminoles defended their land and runaway black slaves who took refuge in their villages against Andrew Jackson's forces who failed to subdue them. The Second Seminole War lasted seven years from 1835 to 1842. During that time, Chief Osceola led his tribe in defense of their land by retreating into the Everglades. The chief was eventually captured and the tribe nearly eliminated.

Under the command of their new leader, Chief Bowlegs, the Seminoles mounted their third and final offense against the United States in a three-year battle, from 1855 to 1858. At the end of the war and in exchange for a small cash outlay, Bowlegs agreed to leave Florida along with about 165 members of his tribe and relocate to Indian Territory in Oklahoma. He died shortly thereafter. Two organized bands and several Seminole families, who never surrendered, stayed behind in Big Cypress in the Everglades and other secluded parts of Florida.

Thus, for several decades, the land of Boca Ratones lay virtually uninhabited until Rickards arrived in 1895.

NO! TO RAT'S MOUTH

The name and location of Boca Raton came about by sheer happenstance. A few misplaced words by a careless mapmaker moved the inlet of *Boca Ratones* more than fifty miles north from its original location in the Miami area to its present home.

Yet the mystery surrounding the city's location has not stirred a fraction as much curiosity as its name. No one knows for sure what the Spaniards had in mind when they named the area Boca de Ratones, but one thing is certain: they left behind a perplexing legacy—one that has followed the city into the twenty-first century.

Most people mistakenly think the name Boca Raton translates into "rat's mouth." And that is somewhat understandable, considering that *boca* is the Spanish word for "mouth" and *raton* sounds like the English word "rat." But the Spanish word for rat is actually "rata." And taken in the context of the time of discovery, *boca* often described an inlet and *raton* (literally meaning "mouse") was a term used to describe a cowardly thief or hauling. Thus, Boca de Ratones—Mouse's Inlet, Hauling Inlet or Thieves Inlet—appeared on eighteenth-century maps.

An 1839 map shows two *Boca Ratones*. The first is located in what is now Indian Creek in Miami-Dade County and the second is located around today's Lake Boca Raton. The name at the original site in Miami eventually disappeared, leaving only one Boca Ratones. By the 1920s, both the "e" and "s" were dropped, leaving the official spelling Boca Raton.

NOW TO PRONUNCIATION

Many have wondered how to accurately pronounce the city's name. To help them, former City Attorney M.A. Galbraith penned this ode in the form of a resolution:

Bo ka' Ra ton'

From "Boca de Ratones," a quaint Spanish name,
Came "Boca Ratone" when the settlers came.
The "e" was discarded, and then it became
Just "Boca Raton." Now who can we blame?
The sound of "Raton" has not quite been the same.

"I've had it with short 'o'," said Councilman Mac,
"It grates on my ear and it throws me off track.
There must be a means for us to fight back,
Proclaim the Right Way, and counterattack!"

Now banned is short "o" as in con or baton,
Or Parthenon, Rubicon, Johnny or Ron.

The "o" in Raton's not like "a" in pecan.
We'll condone only "o" as in valedictorian.

And shunned is the "o" like a "u" as in son,
Or Washington, Arlington, London or none.
We want a long "o." In fact, two, for fun,
Put one in each half of the name and we're done.

Hereafter, forever, let's let it be known
To tourists and purists: "If you should intone
The name of the city of Boca Raton,
Please give it long 'o' as in Old San Antone,
Or pinecone, or corn pone, postpone and rezone."

With this backdrop in place, we now begin our journey.

Making a Living

Digging the Dirt

Land. As far as the eye could see. That's what lured Captain Thomas Moore Rickards and the early pioneers to Boca Raton.

While surveying property for the state around 1892, Rickards bought several tracts of land and an additional fifty acres on the north shore of Lake Boca Raton. Building a two-story wooden house on the east side of the Florida Coast Line Canal and just south of today's Palmetto Park Bridge, in 1895 he brought his wife, Lizzy, and family to the property, becoming Boca Raton's first pioneer. Calling the farm Black Cat Plantation, he cultivated a combination of orange groves and pineapple fields, according to the February 1900 issue of *Homeseeker*, a publication of the Model Land Company.

About the same time, the Henry Flagler–owned Florida East Coast (FEC) Railway laid tracks south from West Palm Beach toward Miami. In the process, depots sprang up at Lake Worth, Lantana, Hypoluxo, Boynton Beach, Linton (later to become Delray Beach) and Boca Raton. Hired by the FEC to be its representative for the selling of railroad property, Rickards's job was to promote the land to agricultural entrepreneurs who would ship their produce on FEC freight cars.

Flagler also engaged Rickards as his agent for the Model Land Company, the land division of Henry Flagler's railway. As such, Rickards platted land owned by the FEC into ten-acre tracts to be sold as homesteads for orange groves and agricultural purposes. He also tended fifty acres of groves owned by the railroad.

By the turn of the century, a small agricultural community emerged from Boca Raton's sand, palmettos and pine forest. While these landowners were mostly white, an early account in the *Homeseeker* suggests that C.W. Blaine worked alongside the farmers: "C.W. Blaine, six acres in tomatoes, one-half acre in beans. Blaine is a darkey and a good one. He is working on shares. Land and fertilizers are furnished him vs his labor. He had no capital but his two hands and a little credit. He has shipped over two hundred crates of beans, selling for $3, and from his six acres of

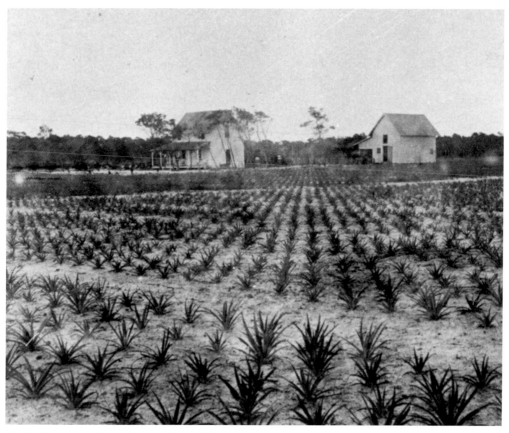

Frank Chesebro cultivated pineapples on his sixty-acre plantation, located where the Royal Palm Yacht & Country Club are today. *Photo courtesy of the Boca Raton Historical Society.*

tomatoes he will clear a good thing." What became of Blaine remains a mystery, the first but not the last for the emerging town.

In 1902 George Ashley Long, a friend of Rickards, brought his wife, Catherine, and their three children to Boca Raton. They too farmed the land, producing tomatoes, eggplants, beans and potatoes.

Frank H. Chesebro and his wife, Jeanette, soon followed, purchasing sixty acres of farmland in 1903. Close on their heels were Bert and Annie Raulerson and Annie's brother, Perry Purdom; his wife, Florence; and their six children. The settlement was growing.

Unfortunately, Rickards's hard work came to an end in 1903 when a hurricane struck the southeast coast of Florida. The storm flooded his fields and destroyed his groves. Disheartened and with an ill wife, Boca Raton's first settler left Florida in 1906 for North Carolina. Long, a Harvard-educated civil engineer, purchased Rickards's second house, located south of Palmetto Park Road and slightly east of the railroad tracks. He also took over his job at the railroad.

Yamato Colony

In 1904 James E. Ingraham, the railroad's vice-president, contracted for a group of Japanese farmers to come to Boca Raton. Under the leadership of Joseph Sakai they formed a community called Yamato (YAH-muh-tow), meaning "large peaceful country," and settled along what is now Yamato Road, near today's Boca Teeca. Locals also referred to this road as "Jap Road."*

The colony labored under difficult conditions to clear the woodlands of pine and palmettos, but by 1908 the thirty-five-member settlement proved successful in cultivating seventy acres of pineapple and one hundred acres of citrus and vegetables. However, that success was short-lived. Later that year, blight wiped out the pineapples and by the time they restored production, competition from Cuba destroyed the domestic market. In the early 1920s, many of the colonists returned to Japan.

One of the farmers who stayed behind was George Sukeji Morikami. A humble farmer, Morikami purchased land west of Delray Beach and continued to cultivate local crops and act as a fruit and vegetable wholesaler. Ending his farming days, in the mid-1970s he donated his land to Palm Beach County. Today the Morikami Museum and Japanese Gardens are visited each year by thousands who enjoy its peaceful gardens, classes in art and flower arranging and colorful festivals.

Another Japanese farmer, Hideo Kobayashi, purchased land in the Yamato Colony area and raised beans, green peppers, eggplant, squash and tomatoes. Alongside him, his daughter Tomiko and sons Sakaye (Theodore) and Tomatsu (Tom) picked vegetables and shipped them north in freight cars. The vegetables were also sold just to the south of Boca Raton at the Deerfield Beach and Pompano Beach Farmer's Markets, both on the FEC railroad tracks.

The Kobayashi family farmed the land until 1942 when the U.S. War Department took possession of the property by eminent domain to make way for the top-secret airborne radar facility, the Boca Raton Army Air Field.

Big Time Farmers

Clint Moore came to Florida in 1925 to build roads, but by the late 1920s, some roads were finished and others underway, while Moore had not been paid for his work. An AP article from an unknown source noted, "Two suits for damages totaling $850,000 were brought against the town of Boca Raton this afternoon by Clint Moore, Delray Beach contractor. No details of the case have been put on record yet but W.Q. Caine of Moore's counsel said the cases were the outgrowth of a controversy over payment for street paving."

Previously a farmer, Moore returned to the land. He eventually owned 4,500 acres on what is now the northern border of Boca Raton and Delray Beach. Called Del Mor in the late 1930s, his farm shipped more than three hundred railroad cars of farm products

* Jap was a common term and referred to persons of Japanese descent. At the time, it was not considered derogatory.

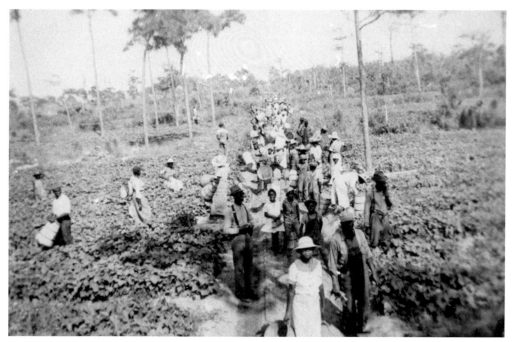

Farm workers pick beans on Butts Farm, a 3,500-acre farm located near where the Town Center Mall is today. *Photo courtesy of the Boca Raton Historical Society.*

per year to Northern markets. According to Roy G. Beck in the 1992 *St. Andrews Sun*, published for the St. Andrews Country Club, Moore had the largest vegetable producing operation in the area and was the largest employer "and it was said in the middle 1930's that if you didn't work for Clint Moore, you didn't have a job."

Beck further stated that in a 1937 citation issued by the State of Florida and the United States government, Moore was "lavishly praised for his work, eliminating the sand fly (no-see-um) in Boca Raton"—praise be to Moore!

During the late 1920s August H. Butts, a farmer from Lake County in central Florida, purchased land vacated during the land bust of the mid-1920s. In the 1930s he became a large landowner and his 3,500-acre farm became the principal producer of green beans in Florida. In season (November to May), Butts's farm employed almost one thousand migrant and local workers.

Agriculture in the western part of Boca Raton continued well into the late 1980s, when development west of the city eventually replaced the vegetable farms with residential housing, businesses, retail stores and parks.

Squatters in Yamato and Sugar Hill

Coming into the area around 1904 were American blacks moving south as well as emigrating Bahamians from Nassau, all looking for work. Having little or no money, these families simply took up residency on vacant land, coming to be known as

"squatters." Employed by the Japanese farmers, the newcomers cleared land and planted and harvested crops.

In *Pearl City, Florida: A Black Community Remembers*, authors S. Evans Jr. and David Lee cited the following:

> Another district was Yamato, known more for its Japanese settlers than its black ones. In 1904 a colony of Japanese farmers was organized by Joseph Sakai, an idealistic graduate of New York University who saw farming colonies as a way of providing opportunities for his countrymen. Japanese landowners farmed large tracts of land in northern Boca Raton…Blacks of Bahamian descent were apparently present in significant numbers. One of the Pearl City informants indicated that there were more blacks in Yamato than in Pearl City in the early years of Boca Raton's History.

Sugar Hill, located west of what is today Pearl City, was another area where blacks settled. It got its name from the fine white sand that composed the hill. In *Pearl City, Florida*, Harriette Gates referred to the squatters as living in scattered "huts."

Families from Sugar Hill toiled as laborers on the agricultural farms. They, along with those from Yamato and in time, Pearl City, eventually grew into a stable workforce that became the backbone of Boca Raton's agricultural economy. But once the winter vegetable season was over and farming came to a standstill, black workers faced a dilemma—how to make a living. Work was available but only on a sporadic basis that consisted mostly of half days. According to Evans and Lee, whites employed blacks to "gather turtle eggs, build fences, grub, lay fertilizer, dig muck, rake roots, mulch, draw plows, capture alligators, build buildings and fish."

SELLING THE DIRT

After Rickards moved to North Carolina, he engaged the services of George Ashley Long to survey and plat a portion of his land set aside for blacks. Long wrote to Rickards, "Now is a good time to start the colored addition to Bocaratone…I have been thinking that the land is Sec. 20 just south of the sec. Line and east of the railroad would be a good place to start…The land would comprise viz: All belonging to F.S. Lewis and T.M. Rickards."

Pearl City wasn't really a city at all but a three-block shrubbery-laden subdivision with three sand streets: Ruby, Pearl and Sapphire. No one knows the true origin of the name "Pearl City," but a credible rationale is stated in *Pearl City, Florida*: "Another plausible and historically consistent explanation is that 'Pearl City' (and perhaps the street name as well) came from the name of a site where a small packing shed existed prior to the community's development. A few blacks were employed at the shed to process pineapple buds. The buds came from a type of pineapple called the Hawaiian Pearl."

Through an auction held on April 26, 1914, blacks bought thirty half-acre lots for an average price of forty dollars each. Thus, Pearl City, the first community for black landowners, formally came into being.

COLORED AUCTION

PEARL CITY

NEXT MONDAY
April 26, 1 p. m.

FREE BOAT RIDE
No Children Taken on the Boat
Free Boat Leaves:
West Palm Beach, City Dock 8:00 a. m.
Boynton - - - 9:30 a. m.
Delray - - - 10:30 a. m.
BIG FREE FISH DINNER AT THE SALE

PEARL CITY A brand new town on the county road. For colored people--- one half mile north Boca Ratone. Beautiful site. Business lots and residence lots.

$5:00 Down, $5:00 Per Month
No Monthly Interest, No Taxes

GEO. A. LONG, *Owner*
Boca Ratone, Fla.

GEORGE FRYHOFER, *Land Auctioneer*
First National Bank Bldg., Chicago

Those Who Buy when a Town is First Opened up make the Money

Tropical Sun Job Print

Representing Rickards, Long auctioned off land in Pearl City to blacks. *Photo courtesy of the Boca Raton Historical Society.*

Alex Hughes, one of Pearl City's first landowners, worked on Chesebro's farm and later became a community leader and activist. Along with John James, Hughes founded the Macedonia African Methodist Episcopal Church in 1918. *Photo courtesy of the Boca Raton Historical Society.*

At the time of the Pearl City auction, whites bought other land at a price substantially less than what the blacks paid. Separated by farms and wilderness, the white and black communities were connected solely by Dixie Highway, the only major road between Miami and Palm Beach.

In 1914 H.D. Gates, a real estate salesman from Vermont, relocated to Boca Raton. Along with his wife, Harriette, they took up residency in a East Indian–style bungalow built on twenty-five acres he called Palmetto Park Plantation. Constructed of concrete block, the house had running water and a telephone, rare conveniences at the time.

Gates farmed the land and raised vegetables, citrus and bananas. He also grew rare fruit and flowering trees as an experiment for the government. In the October 1975 edition of the *Spanish River Papers*, Diane Benedetto—born in 1916 as Imogene Alice Gates, daughter of H.D. and Harriette Gates—recalled her early days on the plantation:

> *The plantation stood on the north side of Palmetto Park Road by the bridge. The road was named by my father after his plantation. It was wild and beautiful then, like some foreign, tropical land, far from the city we see today. Across the canal was a lovely lagoon where white heron fished for minnows among the tiger lilies that grew wild along the banks beneath oaks covered with Spanish moss. It is my favorite memory, that lovely peaceful lagoon. I sat on the banks, filled with wonder, watching the fiddler crabs. I would walk among them, trying to catch one for Peter, my pet coon. Pete would wash it in the canal, then scurry among them trying to catch another.*

Gates's exuberance for the small community bubbled over into conversations with friends and business associates across the country, touting the abundance of land bargains in Boca Raton. To accommodate guests arriving to see this opportunity, he built several small cottages on his property.

A number of simultaneous events prepared Boca Raton for the land boom of the 1920s: aggressive real estate promotions by Gates and other developers, the hard surfacing of Dixie Highway and the extension of Ocean Boulevard (A1A) south to the southern county line.

Gates's real estate acumen brought LaFayette Cooke, an Alabama businessman and banker, to Boca Raton. Showing him land south of Palmetto Park Road and east of Dixie Highway, in 1922 Cooke formed the South East Coast Land Company and purchased five hundred acres. He then asked his son-in-law, Jones Cleveland (J.C.) Mitchell, and daughter, Floy Mitchell, to oversee his land holdings. On October 1, 1923, the Mitchells arrived in Boca Raton.

For the next couple of years land sales stalled, while to the north and south of the small town, developments were sprouting like weeds. Tourists traveled south and often stopped in Boca Raton but the small community had no hotels to accommodate such guests so visitors camped out wherever they could.

A History of Boca Raton

Tin Can Tourists

Diane Benedetto referred to them as "Tin Can Tourists" in her writings. They were Northern folk who rolled into town in the early 1920s in their Model T Fords loaded with camping gear and canned goods. Escaping the frigid winters, they came to spend several months in the warmer climate of Boca Raton:

> *The women wore those horrible knickers with sailor middy blouses in khaki. They would park their cars any place that looked like a good camp spot, unload their paraphernalia, and dig out their can openers. They put up tents or built palm frond shacks. There were many cases of ptomaine poisoning among these tourists as they did not have any way of keeping their food cold. Some did have iceboxes but it was not easy to get ice. Ice was shipped in on the train and it melted sometimes before you could get it, so many had to manage without it and the heat was so intense, things would sometimes spoil within an hour.*

It wasn't until April 15, 1925, that things turned around for the obscure community. The economy, once so dependent upon digging the dirt, was soon to focus on selling it.

The Dirt Boom

The well-known and highly successful Palm Beach architect Addison Mizner brought visions of grandeur to Boca Raton when plans were announced for a 1,600-acre residential/resort development. The development was to include a 1,000-room oceanfront Spanish-style hotel, Castillo del Rey, complete with casino, two golf courses and polo field. Construction costs of the hotel alone were estimated at $6 million. Seemingly overnight, Boca Raton became the hottest real estate market in Florida.

The Mizner Development Corporation, bolstered by support from chairman of the board T. Coleman du Pont, offered the first lots for sale on May 14, 1925, and logged over $2 million in sales. With its second offering two weeks later, another $2 million in lots sold. The Ritz-Carlton Investment Corporation, owner of the Ritz-Carlton chain of elegant hotels, negotiated to take over the Castillo del Rey but wanted the hotel redesigned. In the meantime, they started construction on a smaller 100-room inn on the west side of Lake Boca Raton. It was called the Ritz-Carlton Cloister Inn. Along with the inn, several Mizner-designed residential communities, including Floresta and Spanish Village, began to take shape.

Construction in Boca Raton created high demand for skilled and unskilled laborers. The workers cleared land, built and paved roads and constructed houses and bridges. As *Boca Raton: A Pictorial History* states, "By the end of October 1925 the Mizner company reported that over two thousand workers were leveling and grading the streets in the new development."

On February 6, 1926, the Ritz-Carlton Cloister Inn opened amid much fanfare, planting Boca Raton firmly on the Florida map and opening the area for the first time to a large influx of tourists.

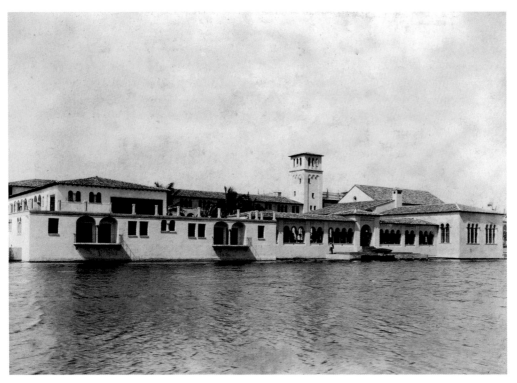

Architect Addison Mizner designed and built the Ritz-Carlton Cloister Inn, which opened in 1926. *Photo courtesy of the Boca Raton Historical Society.*

The Dirt Bust

The loss of du Pont as chairman of the board dealt the Mizner Development Corporation its fatal blow in the latter phases of construction of the Cloister Inn. When he pulled his endorsement other financiers questioned the viability of the Boca Raton development. Without adequate financial backing, by the spring of 1926 the company failed to meet payments of promissory notes. As contractors got wind of Mizner's situation, they filed liens against the corporation, and by fall the Mizner Development Corporation faced bankruptcy. With only twenty-nine homes completed in Floresta and a handful in Spanish Village, Mizner's dream came to an end.

In one short year, the real estate boom fizzled, yet Mizner's dream had thrust Boca Raton into the limelight and his biggest achievement, the Cloister Inn, would impact the community for decades to come.

From Camel to Elk

After Mizner's downfall, the city needed to attract new residents. One of the ideas put forth by J.C. Mitchell, president of the chamber of commerce, was to erect a giant camel at the entrance to the city. Benedetto describes what happened:

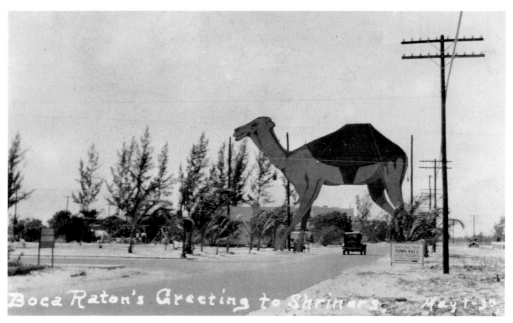

To attract Shriners' attention on their way to a Miami convention, in 1928 the city erected a camel over Dixie Highway. *Photo courtesy of the Boca Raton Historical Society.*

One winter we heard the Shriners were going to Miami for a convention. Boca Raton was never heard of at that time and it used to really annoy us that no one knew where or who we were. The Commissioners had a meeting and this problem was discussed. The idea was born to create a camel, the Shriner's symbol, that would arch the entry to Boca Raton. My father wrote a poem about it that will explain the impact it must have had on all who saw it. We were all so proud of the camel. It was so successful to us that when the Elks came another year, the townspeople built an elk across the highway. Imagine doing that now.

In the summer of 1928, the camel underwent reconstructive surgery. With the hump removed, a new paint job and a set of fake antlers, it emerged as an elk just in time for the Elks' July convention in Miami.

In large bold letters on its back, the elk welcomed visitors by stating: "Hello Bill! Welcome to Boca Raton." A letter from the Elks' magazine dated May 17, 1977, explained the unusual greeting, "Hello Bill!":

There are many stories about "Bill." The most plausible is that Bill was the workhorse at one of the early conventions. Everyone with a question was sent to Bill. Since no one knew what Bill looked like, the greeting became, "Hello, Bill?" Within a very short time this was a greeting among Elks across the nation.

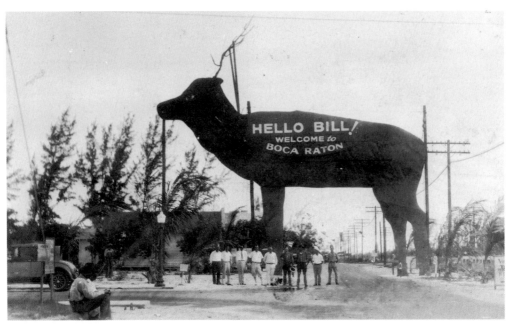

Undergoing a transformation, the camel emerged as the world's largest elk later in July to welcome Elks members traveling south to Miami. *Photo courtesy of the Boca Raton Historical Society.*

Enter Geist

In 1927 Clarence H. Geist, a former Mizner backer, paid $71,000 for the Cloister Inn and acquired $7 million in Mizner debt. He enlarged the inn, adding numerous amenities, and renamed it the Boca Raton Resort & Club.

Naturally, the addition of such amenities required a multitude of service personnel who would meet every need of the club's very demanding members and guests. When the club opened for the 1929–30 season, personnel from Boca Raton and as far away as West Palm Beach staffed the upscale facility.

Diane Benedetto recalled the changes that took place with the completion of the inn:

> *In the early days we didn't know any millionaires. If someone had a hundred dollars they were millionaires. Then along came Mizner to build his exclusive Club, the Cloister. We hardly knew the meaning of exclusive. We were like poor kids at Christmas looking in a window filled with toys and shining baubles. It was something one dreamed of but had never known. Soon we learned that Mizner ran out of money and Geist bought the hotel. He took over the town. He was king. Things changed. Every fall the townspeople put on their clean shirts and ties, slicked back their hair, put on their best dresses and went to watch the arrival of the great millionaire in his private train.*

Bernard and Gerald Turner were sons of Harold Turner, groundskeeper at the Boca Raton Resort & Club for fifteen years. In a *Miami Herald* interview on June 25,

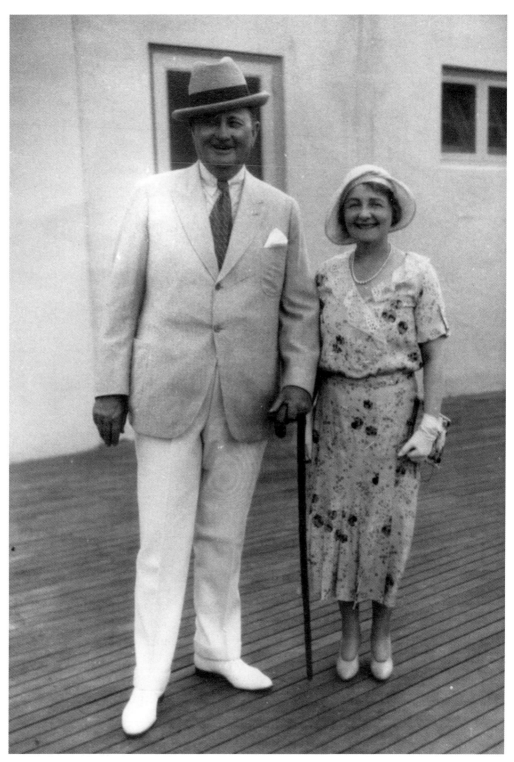

Clarence H. Geist and his wife, Florence, arrive at the Boca Raton depot. *Photo courtesy of the Boca Raton Historical Society.*

1989, they described Mizner and Geist as "larger-than-life" figures. Here's what they said about Geist:

> **Gerald:** *Mr. Geist had a sculptor come over from Italy. There was a huge fireplace. Geist had this Italian sculptor do the mantelpiece real fancy. The sculptor got through, and he asked Mr. Geist, "Isn't that perfect?" Mr. Geist said, "It's too perfect," and he picked up his walking cane and knocked some of it off to antique it.*
>
> **Bernard:** *He was a crusty old guy. Very intimidating. As a page boy at the club, I'd see him all the time, and I'd try to stay as far away from him as I could get. He was always nice to me. He would pat me on the head. He chewed tobacco and didn't care much where he spit the juice.*
>
> **Gerald:** *And he expected that to be cleaned off. He also had a reputation that he loved jokes. He would go out and play golf at the club with various people from all over the world. He would have his chauffeur follow him around the golf course. If somebody told a joke that he really wanted to remember, he would summon his chauffeur, and the chauffeur would get out a pad and write it down.*

Many Boca Raton black residents worked at the prestigious club. Henry James, a resident of Pearl City, recalled:

> *Now I mentioned that blacks worked at the Boca Raton Hotel & Club. There were blacks in several jobs. They had caddying, they had dishwashers. A lot of guys worked in the kitchen and the pantry or they would do the cleaning. There was busboys, but blacks could not be waiters and waitresses down there. They imported all their waiters and even the maids and things would come from the North. You see, the whole thing was this guy who owned this club, he was a man from Philadelphia.*
>
> *You've never seen a segregationist like this kind of person. I've met him so many times. Clarence Henry Geist was his name. He'd say "nigger" in a minute. You could be standing right there, and he'd call you out like that: "Yes, that old nigger..." he'd say it like that. Blacks never got paid the same as whites at that club.*

The stock market crash of 1929 ushered in the Great Depression. The agricultural base that had been established several decades before, coupled with the lavish Boca Raton Resort & Club, continued to provide a livelihood to area residents that many of the nation's other communities lacked. When Geist died in 1938, the club reverted to a trust, with Geist's wife, Florence, acting as its manager.

Businesses Emerge

In the early years, food in Boca Raton was attained as easily as stepping onto the beach or out your own back door. The ocean teemed with snapper, shrimp and turtles. Canals provided largemouth bass and catfish. On land, deer, squirrel, raccoon, possum, duck,

quail, wild turkey, dove and rabbits were plentiful. On occasion, wildcat or alligator tail graced dinner tables. Most early settlers had their own vegetable garden and mini-farm where they raised chickens, hogs and cattle.

Residents made jellies out of guava, coco plum and sea grapes. Orinoco, a type of plantain, was baked or fried. Fruits such as mangos, avocado, figs, sand pears, persimmons and Surinam cherries grew in abundance.

For other food or supplies, residents traveled south to Fort Lauderdale or north to Delray Beach and West Palm Beach. But as the community grew, residents needed stores that were more accessible. Soon, small businesses dotted the landscape.

Early on, Thomas Moore Rickards's sons operated a small commissary from their home on the East Coast Line Canal (now the Intracoastal Waterway), according to Frank Chesebro's memoirs. The boys erected a chain across the canal and collected tolls from passing boats like the *Eleanor Kitty*, a tugboat, which carried supplies from Palm Beach to Miami on a biweekly basis.

By 1923 the main store in the community was a commissary owned and operated by Mr. and Mrs. C.W. Young. A smaller grocery store, owned by Morris Stokes and Tony Brenk, served the farmers west of town at the corner of West Palmetto Park Road and Northwest First Avenue.

With the addition of new residents, more businesses emerged. In 1925 the Bank of Boca Raton was established at Boca Raton Road and Federal Highway. But the building bubble burst and the bank closed its doors in 1928.

A St. Louis, Missourian, Harry Brown, and his son, Herbert, opened a small sundry store in 1931. Within three years, they enlarged the store to include a restaurant and package liquor store. In 1941 they remodeled once again and added a bar. The establishment became known simply as Brown's.

Mr. Guy Bender from Minneapolis set up an automotive business on the east side of Old Dixie Highway three blocks north of Palmetto Park. Around the same time, Blackman's Restaurant and Filling Station operated at the corner of Federal and Palmetto Park Road.

Mr. and Mrs. Max Hutkin arrived in Boca Raton in 1936 and opened a small grocery. The September 13, 1953 edition of the *Delray Beach News* noted the following regarding some unwanted guests the Hutkins encountered when the store first opened:

> *"They were huge things and so brazen that we weren't surprised to see them casually stroll along the counter tops as we waited on our customers, practically snatching their purchases out of their hands," Hutkin reminisced.*
>
> *Astonished one day when a small "cracker" boy walked into the store with a huge black snake coiled around his waist, the Hutkins queried as to the snake's usefulness. Rat catching was the snake's specialty, the boy told them. Needless to say, the boy left the store minus a snake—and one dollar richer!*
>
> *Quickly making a hole in the ceiling large enough to admit the snake, the Hutkins hoisted the reptile to what was to be its home for sometime. Max claims the minute the rats discovered the presence of the newcomer, the noise they set up was unbelievable!*

Guy Bender owned the first gas station in Boca Raton, located at the corner of Palmetto Park Road and Federal Highway. Pictured here (left to right) are Clifton Harrell, the second owner; Paul Sellers; and Marion "Cap" Edwards. *Photo courtesy of the Boca Raton Historical Society.*

Scurrying and scratching to make their exit, over the attic floor, down the walls, for minutes the building fairly rocked with their activity.
Ten minutes later, Max claims, there was a great silence—and, no more rats!

By 1942 Boca Raton had a small airport and a handful of businesses—two general stores (Max Hutkin's and Tony Brenk's), two gas stations, a roadside restaurant, two taverns (Zim's and Brown's), a bus terminal, railroad depot and, of course, the private Boca Raton Resort & Club.

In 1947 Gus Cicala bought his first cab and opened Gus' Cab Service. In the same year, two hardware stores also opened—the B and M Hardware Company and Brown's Plumbing and Hardware.

The Whitehouse Motor Lodge, Boca Raton's first motel, opened in 1948. In that same year, Boca got its first beauty parlor when Mr. and Mrs. Jerry Jollie from New York City opened Maison Jollie.

Within Pearl City, early residents purchased groceries from mom-and-pop stores called Powell, Miller or Wright after their owners. For major needs, they traveled to Delray Beach or Fort Lauderdale, where more black-owned stores were available. After desegregation, the Pearl City groceries closed, finding it difficult to compete with larger-volume, lower-priced chains. Eventually, blacks assimilated into the white retail community and the black groceries closed.

One of the most successful businesses was Tom's Place, owned by Tom Wright, a black man from West Palm Beach. Tom served "soul food" and barbecue out of a

Pearl City house located at the corner of Glades Road and Dixie Highway. Sporting an informal atmosphere, it was patronized mostly by blacks with a few whites occasionally drifting in. During the 1970s and 1980s however, whites "discovered" Tom's Place and it quickly outgrew its converted house.

The restaurant underwent an expansion in the mid-1980s. With the demolition of three Pearl City houses, it emerged with a neo-Spanish façade complete with stucco walls and red tile roof. Customers packed the restaurant, but inadequate parking soon became a nuisance to neighbors. In 1988 the restaurant closed and Tom built another restaurant on North Federal Highway. It was highly successful until 2004 when Tom and his wife, Helen, closed the restaurant to consider their options. Two months later he suffered a stroke and several days later Helen died. Tom died in February 2006 but his children kept his legacy alive by opening Tom's Place on Palm Beach Lakes Boulevard in West Palm Beach.

The War Years, 1942–47

The war brought the Boca Raton Army Air Field (BRAAF) to Boca Raton at a time when the rest of the country was feeling a great economic pinch. The Post, a 5,860-acre top-secret military installation, helped sustain the community during the 1940s and allowed them to emerge on the upside of the ledger. Because its impact was so profound, the BRAAF merits its own chapter and is discussed in chapter six.

Schine Purchases Club

In 1944 J. Meyer Schine purchased the Boca Raton Resort & Club for $3 million. In January 1945, after its release by the military back to civilian control, tourists returned to the club's hallowed halls and magnificent guest suites. He later renamed the luxurious retreat the Boca Raton Resort & Club.

Postwar Business Boom

With the closing of the Boca Raton Army Air Field in 1947, the business community took a dramatic surge forward. Buildings vacated by the military sold at a fraction of their original construction costs, and new businesses moved into the area. In addition, former officers' quarters were purchased and converted into apartments for employees. The postwar boom had arrived.

Mr. J. Deutch purchased the Headquarters Building at the main gate and converted it into a sixteen-unit apartment building. The structure, called Boca Heights, still stands today.

Other businesses that moved into the area included Bo-Del Printing Company, Scranton Metal Casket Works, Colonial Packing Company, Wats Manufacturing Company, Sun and Sea Paint and Varnish Company and the Sjostrom Machine Company. Domina C. Jalbert established an aerology laboratory in one of the buildings where his inventive airfoils changed the entire concept of kite and parachute design.

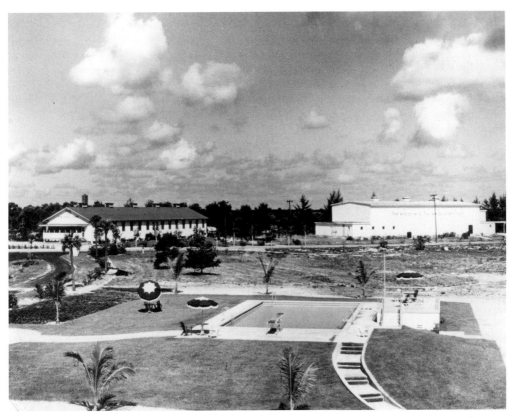

After the war, Ira Lee Eshleman made one of the largest land purchases, buying thirty acres and two buildings. The conference center was named Bibletown USA. *Photo courtesy of the Boca Raton Historical Society.*

In 1950 Boca Raton's first department store opened. Owned by Mr. and Mrs. Frank Roadman, it was located next to the Boca Raton Post Office. In 1952 Robert Ghiotto and Charles Davey opened their law offices with Ghiotto serving as town attorney.

Bibletown USA

Reverend Ira Lee Eshleman made one of the largest single purchases of BRAAF land and buildings for a winter Bible conference when he purchased thirty acres and two buildings for $50,000. The complex was christened Bibletown USA, but in 1967 the name was changed to Boca Raton Community Church when Eshleman left to become chaplain of the National Football League.

Chamber of Commerce

While the first chamber of commerce was established in Boca Raton in the 1920s, few details are known. But the postwar business boom offered the town an opportunity to reestablish the chamber, allowing it to grow into the indispensable organization it is today.

With the urging of H.D. Gates, W.P. Bebout and several businessmen, Mayor O'Donnell formed a committee to investigate the establishment of a Boca Raton Chamber of Commerce. Needing an estimated $2,500 to get the organization started, Max Hutkin, Ray Lasher and Conn Curry canvassed local merchants for a $25 membership fee. The committee also visited the Pompano Beach and Delray Beach chambers to glean information about operations and marketing. Deciding to move forward with the chamber, Mayor O'Donnell, Boca Raton's first physician, became its president.

The chamber's headquarters opened in 1952 in the old community church. Shortly after, it moved into its own building at the corner of North Federal Highway and Boca Raton Road. The organization had a staff of one who greeted visitors and members and ushered them onto the country front porch where they relaxed on hot afternoons.

Enthusiastic members initiated several community projects—Christmas lights on Federal Highway, stop sign installments, railroad crossing protection, enforcement of sign ordinances, road resurfacing and traffic light synchronization. And to attract new associates, members often rode through town ringing the bell on Old Betsy, the community's first fire truck.

What was once a membership of four attorneys, a dentist, a bank, a savings and loan association, three insurance agents and two accountants grew into a successful 1,700-member organization by 2006.

Africa USA

John Pedersen, fifty-five, was a stranger to Boca Raton, according to Irene Konrad in her book *Farewell Africa U.S.A., Hail Camino Gardens*. However, that didn't stop Pedersen from wandering into a downtown confectionary shop and proclaiming, "This is the deadest town I've ever seen. How would you like to see it liven up? I can make this city."

At the time, the town had 992 residents and, as previously noted, its economic base revolved around agriculture and the Boca Raton Resort & Club. But on the horizon, tourism was about to thrust the town into national headlines.

In 1950 Pedersen bought 350 acres of land for twenty-five dollars per acre at a town auction. Soon, giraffes, peacocks, camels, hippopotamuses, elephants, antelopes, Abyssinian asses, zebras, gazelles, ostriches, chimpanzees and spider, squirrel and capuchin monkeys arrived from Kenya and Tanganyika Territory to take up residency in a 177-acre Boca Raton reserve.

On March 10, 1953, the largest private zoo in the United States opened for businesses. It was called Africa USA.

Upon entering Tanganyika Territory, guests were greeted by Machakas, a Masai warrior. His face painted in native fashion and his body covered in leopard skin, he wore a feathered headdress and clutched a spear and rhino-hide shield. The warrior—really Oscar Bradley, a black man from Pompano Beach—had a stutter and an engaging sense of humor, according to George Gehris, who was employed at the park from 1956 until it closed in 1961.

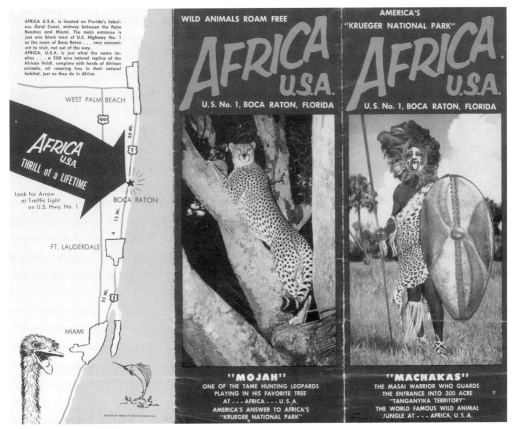

Africa USA opened in 1953 and averaged over two thousand visitors daily. *Photo courtesy of the Boca Raton Historical Society.*

Open-air, rubber-tired trains transported tourists through a vast Nairobi savanna where unrestrained animals roamed grassy plains. The park included Zambezi Falls, a 30-foot-tall cascading waterfall that Konrad noted, "roared through 800 feet of flower-decked rapids," and the Watusi Geyser that shot 160 feet into the air every hour.

One of the best-loved attractions was Mojah and Mbili, a pair of cheetahs. After serving as a park guide for several years, Gehris became their handler and remembered them well: "I'd play with the cheetahs and when I was tired I'd walk away, but if they weren't tired they'd jump on me. I'd come home with my clothes torn and scratches all over me." Later, the cheetahs were featured as Emperor Nero's wife's personal pets in the Academy Award–winning film *Quo Vadis.*

Arlene Owens, who grew up on forty acres of wooded land just to the west of the park, remembered: "There was a high fence between the park and our property and we used to watch the animals. Monkeys that had escaped were always in our yard and the peacocks visited too."

Africa USA brought 300,000 tourists a year to Boca Raton. Its impact was so profound a photo of the attraction graced the cover of *LIFE* in 1960. And although it remained a

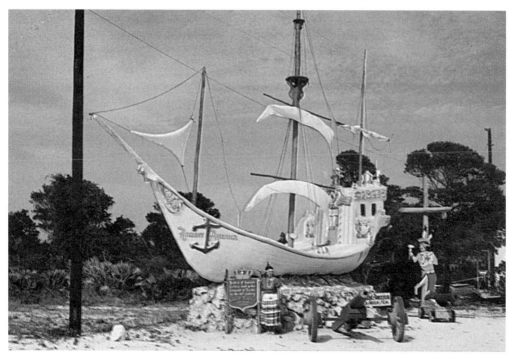

Esmond G. Barnhill purchased twenty-four acres that contained Indian mounds and turned the property into a tourist attraction called Ancient America. *Photo courtesy of the Boca Raton Historical Society.*

flourishing tourist destination, the rumored discovery of the deadly African red tick and plans of development forced it to close in September 1961.

After closing, the park became Camino Gardens, a 450-home residential community. For years, peacocks continued to visit the residents.

Ancient America

To further attract tourists to Boca Raton, Edmond G. Barnhill, said to be a wealthy treasure hunter and adventurer, bought twenty-four acres of land on ancient Indian burial mounds. After thorough investigation by archaeologists, he turned the mounds into a tourist attraction called Ancient America. In her book, *Boca Raton*, Cindy Thuma said the attraction "taught visitors about the life and lore of the area."

A thirty-foot-long concrete replica of a Spanish ship, purportedly modeled after that of Ponce de Leon on his search for the fountain of youth, stood at the entrance and drew visitors. Inside the attraction were displays of pirate chests, shrunken heads, doubloons, arrowheads and chain mail armor. But when attendance dropped, the exhibit languished and Barnhill closed it in 1958.

Several attempts were made to save the Indian mounds and turn the property into a state park. But when Palm Beach County Commissioners chose to support another Indian site, the property was sold to developers. Boca Marina Yacht Club, an upscale

gated community, currently occupies the site. And while the Indian mounds remain, they are no longer open to the public.

From 1920 to 1960, the Boca Raton Resort & Club, Boca Raton Army Air Field, Africa USA and Bibletown USA succeeded in bringing hundreds of thousands of visitors to Boca Raton. That past was about to pay off.

Arvida and the Next Land Boom

J. Meyer Schine owned the lavish Boca Raton Resort & Club for eleven years until 1956, when Arthur Vining Davis, chairman of the board of Alcoa Aluminum, purchased it for $22.5 million. An additional fifteen hundred acres, a partially completed shopping center and 1.5 miles of beach from Palmetto Park Road south to Deerfield were included in the deal.

Davis formed the Arvida Corporation in 1958. Retaining a majority of the stock, he sold the rest in public offering, raising $5 million. This became down payment for development costs of Boca Raton's first luxury subdivision called Royal Palm Yacht & Country Club, located on the south side of Camino Real Road across from the Boca Raton Resort & Club. The 742-home community became the first of dozens of subdivisions that Arvida would develop, ushering in another Boca Raton land boom.

IBM and the High-Tech Explosion

High-tech giant International Business Machines (IBM) found Boca Raton very attractive and in the late 1960s bought several hundred acres north of the city. The large research and development complex was designed to contain its own electrical substation, water pumping station and railroad spur. Construction began in 1967 with dedication of the campus held in March 1970.

At this facility, Phillip "Don" Estridge and his team of twelve engineers gave birth to the IBM PC, which later eveolved into the IBM PS/2. Jan Winston, Estridge's longtime friend, neighbor and coworker, stated this about Boca Raton: "It was a sleepy town in those days, not sophisticated like it is today. Then, it was only old people and IBM employees. You could stand outside watching the kids play and have a departmental meeting."

By 1986, 8,600 employees occupied the IBM campus. Joining the corporation during the 1980s were Mitel, Sensormatic, International Controls, Eltech, Siemens, Burroughs, Fasco, Megasystems, Rodime and Aptek Microsystems. In fact, so many high-tech companies came to area, it was dubbed "silicon beach."

When the IBM manufacturing plant relocated to Raleigh, North Carolina, in 1989, the Boca Raton plant was converted into offices and laboratories. Developed in these buildings were the groundbreaking OS/2 operating system and Voice-Type Dictation, known as ViaVoice voice-recognition software.

IBM sold its faclities in 1995 to Blue Lake Real Estate, which in turn sold it to the T-REX Management Consortium. IBM's Building 051, a highly secure and secretive

The Royal Palm Plaza, dubbed the "Pink Plaza," was a collection of restaurants, boutiques and specialty shops. It was also home to Jan McArt's Royal Palm Dinner Theater. *Photo courtesy of the Boca Raton Historical Society.*

complex that was separated from the former main IBM campus by Spanish River Boulevard, was sold to the Palm Beach County School District and converted into Don Estridge High-Tech Middle School. The school is currently home to Don Estridge's personal IBM computer.

Shopping

By the 1960s, the city had a large enough population to sustain a shopping mall. The Boca Raton Mall, previously located on the current site of Mizner Park, was anchored by Jefferson's and Britt's department stores and offered the welcomed convenience of nearby shopping.

Just south of the mall, Royal Palm Plaza opened in 1962 anchored by Boogaart's Market. Because the plaza was unable to attract larger chain stores, the developers concentrated on smaller, specialized ones. Dubbed the "Pink Plaza" because of its rose-colored façade, the Mediterranean-style shopping center was the ultimate shopping experience with unique shops, boutiques and intimate restaurants.

As Boca Raton's population exploded west of the city, the area needed an upscale shopping mall. In 1979 the Town Center at Boca Raton opened on Glades Road just west of I-95. While residents agreed it was a welcomed addition to the community, the mall sucked shoppers from the city and soon stores in the older Boca Raton Mall began to close. Royal Palm Plaza also felt the pinch.

In the late 1980s, a master plan to revitalize downtown included the restoration of city hall, expansion of Sanborn Square, a park located on Federal Highway across from the old city hall and replacement of the Boca Raton Mall with an upscale multiuse complex.

A History of BOCA RATON

Boca Raton Mall was demolished, and in 1991 Mizner Park rose from its ashes. With the look of a Mediterranean suburb, it is a mixture of retail shops, art galleries, fine restaurants and condominiums. On the north end is located the Boca Raton Museum of Art; adjacent to it is a large outdoor amphitheater.

Royal Palm Plaza also underwent a face-lift and name change to Royal Palm Place. Though many shops and restaurants remain, some were replaced by high-rise condominiums and office buildings. And as a tribute to the city's heritage, a bronze statue of Addison Mizner was erected at the southwest corner of the complex.

Thanks to the early pioneers, who laid the groundwork for the the city's future, Greater Boca Raton continues to attract myriad companies, each desiring to be part of its thriving business community.

Faith and Leadership

Faith

Faith and religion played a vital role in Boca Raton's early history and were the catalyst for its transformation into what it is today. Even racial separation and the Jim Crow mentality that prevailed throughout the South—including Boca Raton—didn't deter the community from becoming all it could be. Separately, the white and black communities' commitment to the Christian spirit allowed Boca Raton to survive the country's decades of segregation and emerge without the racial conflicts that supplanted reason in many other American communities.

Early African American Congregations

The black community in Pearl City organized home church congregations around 1918. Although it is unclear whether the Baptist or the Methodist church was the first to organize, both had tremendous influence on the black community.

Alex Hughes and John James founded the Methodist church, called Macedonia Chapel AME Church. At first, the congregation met for "Sabbath School" in a room in Hughes's home but later a brush arbor was built for services.

In a 1972 interview, Hughes stated, "In 1924, we got our church." In this building, Pastor Brookens preached the Word.

The Reverend J.H. Dolphus, along with other strong parishioners such as Leroy Parker, Will Demery and Minor Jones, founded Ebenezer Baptist Church in November 1918. Dolphus served as its first pastor. Amos Jackson recalled that the two churches became the cornerstones of the black community:

> *We went to church a lot. There really wasn't anything else to do, like on Sunday and evenings. You'd get up and the kids would go to Sunday school, most of the time their parents would go with them and you'd stay to eleven o'clock service. You did meet people because lots of the people came. It just wasn't nothing to do but go to church.*

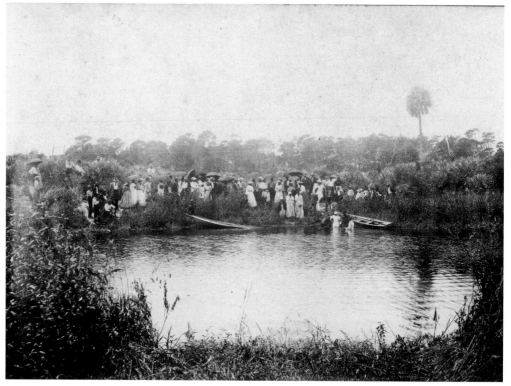

Members of the black church are baptized in the Hillsboro River. *Photo courtesy of the Boca Raton Historical Society.*

Some people say, well, with blacks the church is more than just a place to worship. What they meant by that is that it's a place where people go and meet people. It's a place to get some suppers. If somebody felt that they have been treated wrongly, the church people in the neighborhood would get together and do what they could do about it.

Apparently Hughes and his wife attended different churches, and on Sunday he sat in the Methodist church while she sat in the Baptist church. But early residents of Pearl City say that wasn't so unusual because everyone attended both churches:

If you say you are a Baptist-Methodist then you are a member of the Baptist Church. If you say you a Methodist-Baptist, you are a member of the Methodist Church. The way it was years ago, we went to Macedonia, the Methodist Church, just as much as we did Ebenezer. The community at this time was so small they had Ebenezer one Sunday and Macedonia the next Sunday. This is the way it was, see.

Both churches held social events, including fish fries at the beach, Christmas celebrations and Easter plays. Members also got together and formed musical groups.

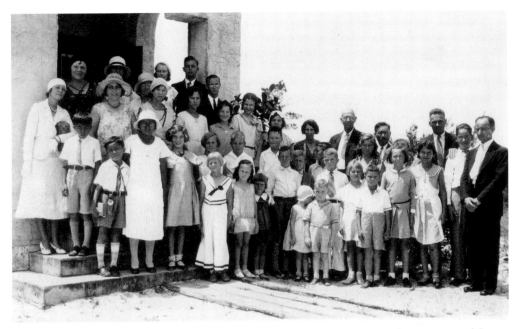

Boca Raton Methodist Church congregants gather for a group photo in 1932. *Photo courtesy of the Boca Raton Historical Society.*

Early "White" Congregations

Prior to a physical church, white Christians worshiped together in the city's one-room schoolhouse. There, the church community organized itself and prepared for construction of its first church building.

The white Christian community broke ground for the Boca Raton Community Church on October 28, 1925. Thirty-three Boca Raton families, including several early pioneers—Bert Raulerson, Frank Chesebro, George Ashley Long and H.D. Gates—along with the Mizner Development Corporation and South Florida Sales Company, contributed a total of $4,185 toward its construction. Funding, building and supporting the church became a community effort.

The church was completed before the end of the year and Reverend W.C. Fountain, a Methodist pastor from the Delray Beach Methodist Church, presided over its first service. While the church property was deeded to the First Methodist Church of Boca Raton in 1928, it continued to function as the Boca Raton Community Church.

Because most Boca Raton residents were Methodist, in 1953 they initiated an effort to build a Methodist church. To raise funds, Mrs. Lavonne Mouw held annual musicals and Mrs. Hildegarde F. Schine, wife of J. Meyer Schine, owner of the Boca Raton Resort & Club, assisted her. With their fifth musical, to benefit the organ fund, the pastor acknowledged their devotion to the cause in supplying the church with choir books, robes, a piano and money in the bank. He then suggested that they give a concert for another charity.

In the May 1976 Spanish River Papers, Hildegarde Schine told this anecdote: "Mrs. Mouw turned to me and said, 'Well, I guess we've fixed up your church.' 'But,' I told her, 'I'm not Methodist, I'm Jewish!' And I thought she was Methodist, but she wasn't either. She was Presbyterian!"

The First Methodist Church broke ground on February 22, 1957, on Northeast Second Avenue and held its first church service in the new building on July 14. The thriving church still stands there today.

Though the Boca Raton Community Church lost most of its parishioners to the new Methodist church, it later became home to St. Paul Lutheran Church. As that congregation grew, the church was again abandoned. In 1962 it became home to the Debbie-Rand Memorial Service League Thrift Shoppe.

After several good months, the thrift store outgrew the structure and it stood empty for several years. In 1968 the little church that had faithfully served the community for so many years was demolished to make a parking lot for the First Bank and Trust Building. During the demolition, an inscription was discovered on a square of Dade County pine. It read: "This platform built December 10th, 1927 by J.M. Tanner, F.W. Riley, John F. Rushing, Marian Thomson, Harry Chesebro, George W. Race, assisted by Mrs. Rushing and A.J. Williams."

Brad Whittington of Concepts Development, who handled the demolition of the building, reportedly rescued the wooden plaque. Today, its whereabouts are unknown.

Jewish Roots

Max and Nettie Hutkin found it difficult to acknowledge their St. Louis shoe store had failed. But with few options, the Jewish couple packed their belongings and headed for Boca Raton. They would stay with Nettie's brother, Harry Brown, who oversaw the Hermannson family home, a luxurious beachfront house.

Arriving in 1936 and determined to make it in the small community, Hutkin bought a run-down grocery store at the corner of Palmetto Park Road and Dixie Highway. According to Then & Now: The Boca/Delray Jewish Times Anniversary Issue on August 29, 1997: "Workers from the nearby hotel patronized the store and bought goods on credit and the store became a popular meeting spot. Mr. Hutkin became known as 'Mr. Boca.'"

At the same time, the Browns, who were also Jewish, owned a restaurant and bar that became a central meeting place for local residents. During the war, military troops tiring of mess hall food flocked to the establishment. John Mangrum, a soldier stationed at the Boca Raton Resort & Club in 1943, said, "They had the best cheeseburgers and beer. I remember the jukebox and Betty Davis singing, 'They're Either Too Young or Too Old.'"

While the Browns and Hutkins were the first Jewish residents in Boca Raton, the most prominent was J. Meyer Schine, who bought the Boca Raton Resort & Club from the Geist Trust in 1946. A Russian Jewish immigrant, Schine and his wife, Hildegarde, were part of Boca Raton's upper crust. Hildegarde was quite active in social activities around

Boca. As previously mentioned, she held teas to raise money for Protestant churches, and she became intimately involved with the creation of the Art Guild, which later became the Boca Raton Museum of Art.

But even with the arrival of the Schines and their many contributions to the community, all was not harmonious in Boca Raton. Anti-Semitism was alive and well. Just as the early community wanted Boca Raton to remain racially "pure," it also wanted it to remain theologically "pure."

While no one outwardly shunned the Schines, several accounts from Jewish military troops trying to find off-base housing in Boca Raton during the war tell of being turned away. And, after the war, a poster selling real estate touts, "Homesites In Beautiful Restricted Boca Raton Hills." Even Schine told his realtor, Byron Parks, to inform Jewish newcomers looking for real estate that there was "nothing available," according to Peg McCall, longtime Boca Raton resident and former archivist for the Boca Raton Historical Society.

While Christians had established churches, Jews living in Boca Raton during the 1940s and 1950s didn't have a place of worship. "Nor did they have a desire to do so," according to *Then & Now*. But all that changed with the involvement of a Catholic nun in the late 1960s.

Mother de la Croix, christened Mildred O'Connell, was president of Marymount College in Boca Raton, now Lynn University. In "Boca Raton's Jewish Mother," an article in *The Big 30*, she stated, "I picked up the newspaper and noticed that a group of people were attempting to develop a community place where they could begin to worship."

Realizing the Marymount campus had an auditorium that was not being used on Friday evenings, she offered the use of the facility to the small Jewish community for Shabbat services, Friday night Sabbath services. O'Connell stated in "Boca Raton's Jewish Mother":

> *There was still a lot of anti-Semitism here in 1967 in Boca and Delray. I realized that [the Jewish] community was not welcomed in every place in Boca Raton and it just appalled me. We had a beautiful campus—to invite the Jewish community on campus was not a problem. There were no concerns, no discussions, no contracts, no money exchanged, nothing.*

The original ten worshipers became the membership base of Temple Beth El, the first Jewish house of worship, located at 333 Southwest Fourth Avenue in Boca Raton. Today, there are three temples in Boca Raton and several more in unincorporated Boca Raton.

Islamic Influence

The Islamic Center of Boca Raton (ICBR) branched off the Muslim Student Organization at Florida Atlantic University to establish the first Masjid and community center in Boca Raton. Meeting in Plum Park Plaza in 1999, the congregation grew from 40 to 250.

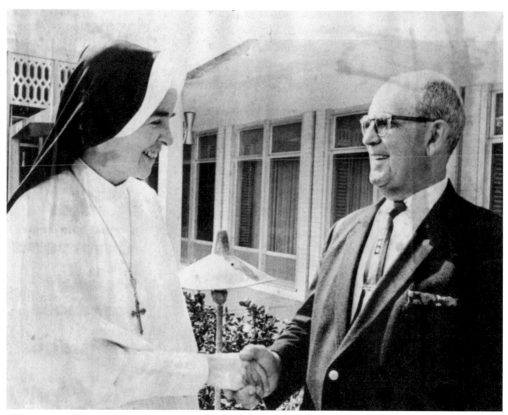

Mother de la Croix and Max Hutkin at Marymount College. *Photo courtesy of Temple Beth El.*

In 2001 the ICBR purchased 3.3 acres on Northwest Fifth Avenue and completed architectural drawings for their new building. In 2003 they purchased the adjacent 3.3 acres and opened the Garden of the Sahaba Academy (GSA), a full-time Islamic school with 20 pre-kindergarten students. (The school occupies former officers' quarters of the Boca Raton Army Air Field). Over the last four years, GSA doubled the enrollment each year and, as of August 2006, is providing scholastic and Islamic education from pre-kindergarten to seventh grade for over 130 students.

ICBR's general Masjid and community operations are currently co-located in the GSA school building. Completion of a new ICBR facility with over 40,000 square feet of space is expected in 2008.

LEADERSHIP

Organizing the Board of Trade

By 1915 Boca Raton was becoming a successful agricultural community, and with its growth came the need for a formalized governing body. That need was met on

> ## BOCA RATONE
> # BOARD OF TRADE
> ### BOCA RATONE, FLORIDA

Stationery masthead from the Board of Trade, established in 1915. *Photo courtesy of the Boca Raton Historical Society.*

August 11, when ten residents gathered to form the Board of Trade. Its purpose was to govern and develop the community.

George Ashley Long served as temporary chairman; H.D. Gates acted as secretary. A week later, the first regular meeting of the Boca Raton Board of Trade was held with the election of the following officers and directors: W.M. Sistrunk, president; F.H. Chesebro, vice-president; H.D. Gates, secretary/treasurer; and Directors H.B. Fultz, B.B. Raulerson, George A. Long and W.J. Sistrunk.

Their first order of business was to investigate the possibility of getting the Boca Raton Inlet opened, as currents depositing sand rendered it impassable. They also wanted something done about vagrants at the depot. In minutes of their November 11, 1915 meeting, the following was noted: "It was voted to write the Section Foreman, of the East Coast Railroad, to take proper steps to remove all loafers from the station platform and to prevent as far as possible the colored population from hanging around the depot."

During the Board of Trade's tenure, telephone lines, paved roads, a bridge, a school and other amenities were successfully brought to the community.

While the growth and development of Boca Raton was indisputably tied to the dedication of early pioneer politicians who laid the foundation for its evolution, it did not come without its share of controversies. Diane Benedetto described one of those times:

> *My people were Northerners. Better known as damn Yankees. I thought it was some kind of disgraceful malady and I felt ashamed that I was different. I was a damn Yankee. Later I learned to say, "I am a Florida Cracker. I was born in Florida." I figured that would set them back. Yet as I was still contending with that my people were bearing the stigma of being damn Yankees and I thought it was sad and I felt sorry for them.*
>
> *The time this problem was most prevalent was at election time. Things got real exciting. The Southerners didn't want any Yankee in office. On election day they came with rocks in their aprons and shotguns. A Yankee better not win.*

The Town Incorporates

The Board of Trade continued to govern until 1925, when the community incorporated and appointed George Long to serve as its mayor. In the first election, 150 registered voters elected five councilmen. John Grover Brown received the most votes and became mayor. In what is known as a council-mayor form of government, the mayor made all decisions regarding the town and also doubled as town judge.

By 1951 Boca Raton outgrew its council-mayor form of government and explored the possible transition to a council-manager form of government. Pat Jakubek shared this story as told to her by Bill Lamb Jr.:

> When Boca was first contemplating converting to the City Manager system from the Mayor/Town Council form of government, feelings ran strong over this issue and its opponents were quite vociferous. What was supposed to be an open meeting to discuss the idea was held, but when one of its leading proponents, Dr. William G. O'Donnell, the town's only physician at the time, attempted to speak in favor of the change he was physically assaulted by opponents and told to sit down and shut up. The next night, townspeople convened at the auditorium [the old school gym] for a truly open meeting with both sides being given ample opportunity to express their views.

Although Bill was only thirteen at the time, he well remembers Doc O'Donnell giving a rousing speech, which ultimately led to the adoption of the change. Bill completes this tale by announcing that his father, William H. Lamb Sr., went on to become the city's first city manager.

Boca Raton became a city in 1957. Since then, many mayors and city managers have had the privilege of serving their constituents.

Mayors and Accomplishments

George A. Long, Boca Raton's first appointed mayor, served his community faithfully from August 1924 to June 1925. Subsequent to his mayoral duties, he became a county commissioner and was instrumental in extending Ocean Boulevard (A1A) northward to Delray Beach. He also served as the town's first postmaster. Upon his death in 1929, the community honored his service by holding his funeral in the council chamber at the town hall, the only funeral ever held there. So many people attended the funeral, some had to stand outside and listen through open windows.

Boca Raton's first elected mayor was John Grover Brown, a Florida native, who served from June 1925 to November 1929. During his tenure, the water system and town hall were constructed and the town purchased "Old Betsy," the community's first fire truck.

During Fred Aiken's term (November 1929–July 1938), ordinance #112 was passed, setting "the limits wherein persons of Ethiopian or Negro race may reside and prescribing the penalty of the violation of the same."

The ordinance prohibited persons of the Ethiopian or Negro race from residing in the town limits of Boca Raton and confined them to limited areas within and surrounding the three blocks of Pearl City. The ordinance did not apply to servants as long as they were actually in the employment of a white person. Violation of the ordinance would be punishable by a fine "not to exceed One Hundred ($100) dollars or be imprisoned in the town jail not to exceed Sixty (60) days, either or both: and residence outside of the said area within the said town by such person for one day shall constitute and be separate offense in violation of the provisions thereof."

No mayor served as long or in such a difficult time as Boca Raton's fourth mayor, J.C. Mitchell, a real estate broker. Serving from 1938 to 1950, he faced the challenge of leading the town through recovery from the Great Depression only to be thrown headlong into World War II. But he rose to the challenge by encouraging the army to bring the Boca Raton Army Air Field to the community. This helped the city sustain a thriving economic base. After the war, Mitchell was equally successful in having air base lands returned to Boca Raton's tax roll. His foresight poised Boca Raton on the cusp of the largest population growth the town would ever see. (See the population chart in the appendix.)

A milestone was reached in the mid-1970s, when residents elected Dorothy H. Wilken. As the city's first female mayor, she served from March 1976 to February 1977 and again in April 1977, after taking over for Mayor Dick Houpana, who resigned amid controversy a month into his second term. She dealt with such issues as "growth management for the city, establishment of park impact fees, the purchase of South Inlet Beach, and topless sunbathers. Wilken was one of the originators of the Citizens for Reasonable Growth, which became a strong support base for her."

Through 2007, thirty-two mayors have served the city. Most served one-year terms, with several serving multiple terms. Each played an important role in the growth and development of Boca Raton from a small rural farming community into the well-run and vibrant city it is today.

BYWAYS AND ABODES

BYWAYS

County Road and the Biscayne Bay Stage Line

Traveling into and out of Boca Raton was paramount to its growth and development, yet initial access to the small community was quite limited. Early inhabitants traveled by boat along the coast or by horse and wagon along inland sandy trails that traversed the very long Dade County. (Originally, Palm Beach and Broward Counties were part of Dade County, which was created in 1836. Palm Beach County emerged in 1909 and Broward County was formed in 1915 from portions of Palm Beach and Dade Counties.)

To travel the region, County Road opened in 1892. It ran from Lantana—north of Boca Raton—south to Lemon City on upper Biscayne Bay in Miami. It was a sandy road traveled by stagecoach or horse and wagon. On a map penned by Rickards in 1900, the road ran through Boca Raton approximately where U.S. Highway 1 is today.

To transport the public along this route, the Biscayne Bay Stage Line was born. Consisting of two mule-drawn springless wagons covered with canvas, the line ran from Lemon City to Lantana. Taking two days to cover the route, the line stopped at a ferry site known as Stranahan Camp located on the New River in Fort Lauderdale where the Stranahan House is today. With three round trips a week, the Lemon City Stage and the Lantana Stage left the same morning, traveling toward each other. After meeting at the New River for the night, the stages swapped passengers and returned to their respective cities. A round trip cost sixteen dollars; one way, ten dollars; and overnight accommodations, two dollars. The stage became obsolete in 1895 when tracks for Henry Flagler's FEC railroad were laid through Boca Raton and passengers traveled by rail.

Frank Chesebro, an early pioneer who came to Boca Raton in 1903, stated in his handwritten history that when he came to the area the roads were nothing but sand and

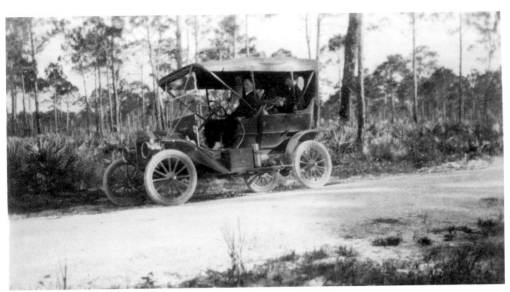

A car travels south toward Fort Lauderdale on County Road. *Photo courtesy of the Boca Raton Historical Society.*

in some places "no road at all." But within a year, rock roads began to emerge. A rock pit in Fort Lauderdale supplied the medium for the roadbed, and convict labor loaded the rail cars that brought the rock to Boca Raton. Chesebro wrote:

> *After the morning train had gone north an engine would bring the 8 cars of rock to the end of the road and space the cars 150 feet apart. Then the cars would be unloaded by hand, two men in each car. One man in the car to fill a box hung on the outside of the car, and another man with a wheelbarrow to wheel the rock to the road just outside the right-of-way where other men leveled it. There was always a race to see who would get unloaded soonest. All were usually unloaded by 2 or 3 o'clock.*
>
> *The rock when dumped on the road was never rolled—that was done by wagons. No autos here then. Horses and mules of course had to be shod and blacksmiths had plenty to do. Some farmers would get a set of farmer's tools and do their own shoeing. Bicycles came in handy about that time.*

By the time Gates arrived in Boca Raton in 1915, a new nine-foot-wide rock road drew a line from Palm Beach to Miami. Harriette A. Gates wrote in her memoirs:

> *That early road was always full of potholes which the rains kept constantly working at. Usually a right front wheel would go into one, then with precision timing the left back wheel would strike another. We used to make weekly shopping trips to West Palm Beach to get Chase and Sanborn coffee and other things the tiny commissary at Boca Raton did not have, and by the time we got home we needed the coffee for a stimulant and a week or so to recuperate.*

Of course, the potholed road referred to above was really Dixie Highway, so called for the lyrical name of the Old South.

Dixie Highway

Carl G. Fisher—entrepreneur, racecar driver and real estate developer—is credited with building Dixie Highway. He already established the Indianapolis Motor Speedway and invented the carbide gas-powered headlight, known as the Prest-O-Lite. But it was the development of Dixie Highway—a network of north-south routes extending from the upper peninsula of Michigan to southern Florida—and Miami Beach that ultimately built his reputation in the southernmost state.

In October 1915, Fisher led the Dixie Highway Pathfinders on a fifteen-car cavalcade from Chicago to Miami, traveling the length of the proposed highway for the first time. Less than a year later, Dixie Highway opened to the public. It stretched from Indianapolis to the foot of the Collins Bridge at Biscayne Bay. This highway allowed Fisher to develop Miami Beach in the early 1920s.

Dixie Highway became the main road into and out of Boca Raton and for a time served as a portion of U.S. Highway 1. In Boca Raton, the road runs on the east side of the FEC tracks, but that wasn't always the case. Originally, the road ran west of the FEC tracks from several blocks north of Boca Raton Road to south of the railroad station and was called Railroad Avenue. Early photos show the road there as late as 1921. However, photos from 1925 show Dixie Highway moved to the east side of the tracks where it is still being used today as the line of demarcation for the numbering of city streets.

Two momentous occasions mark Dixie Highway through Boca Raton. The first was the erection of the camel by the Boca Raton Board of Trade (described in detail in chapter two). The second was the controversial removal of a fifty-year-old banyan tree in 1987 to make way for the expansion of Dixie Highway.

Costs for moving the tree, planted by the Mitchell family, were estimated at $20,000. Residents in favor of having the tree moved rather than removed formed the tree organization SOB (Save Our Banyan). But their efforts proved fruitless and the tree was cut down to make way for the widened road.

Palmetto Park Road

Palmetto Park Road was the first public east-west road in Boca Raton. Carved out of pine scrub, it transitioned from its first roadbed of sand to crushed rock and later to asphalt. Land between the East Coast Line Canal (now the Intracoastal Waterway) and the Atlantic Ocean originally consisted of a hammock of exotic plants and trees—gumbo-limbo, live oak, scrub palmetto, orchids and bromeliads. To get to the beach, one crossed the canal by boat then traversed a narrow sandy path about a half-mile long.

In 1917 Palmetto Park Road was resurfaced. At the same time, a turnstile bridge was constructed over the East Coast Line Canal and a new road replaced the path from the

canal to the ocean. For the first time, Palmetto Park Road ran continuously from the train depot to the beach, where the city also erected the original Palmetto Park Pavilion.

Jake and the Bootleggers

In the mid-1920s, development in Boca Raton increased sharply, requiring the building of more county roads. J.M. "Jake" Boyd, who served as Palm Beach County engineer from 1926 to 1953 and town manager of Palm Beach from 1953 to 1959, came to Boca in 1926 to oversee several road projects. He recalled an unusual experience during his time in Boca Raton in "Roads, Beaches and Bootleggers," written for the *Palm Beach Post Times* and *Palm Beach Daily News* by James R. Knott:

> The Volstead Act [Prohibition] *outlawing alcoholic beverages had spawned many bootleggers lured by promises of quick profit. Quality scotch, gin, wine and brandy were brought by the shipload to the Bahamas' West End. Then, by small boat and airplane, [the liquor] was bootlegged to Florida, the shortest distance being to the beaches of Palm Beach County. The importers had adopted a novel scheme for advising their boats offshore where to land by providing a couple of lookouts, one with a surveyor's transit and the other a pretend roadman, imitating the surveying activity in progress all over the county. The transit provided the telescope to identify the boat and the roadman had his own code of wigwagging the message. I had a crew surveying the Boca Raton beach area, which must have preempted the signal caller, because a boat entered the inlet at Boca Raton and beached in the lake just opposite my transit man. The boatman recognized his mistake and took off on foot, leaving a boatload of choice beverages in their gunnysacks. The surveyor contacted me, and after pondering a little, I sent a truck and took a full truckload to the garage of my rented house, to be stored there until I could ponder enough to notify the sheriff's office.*
>
> *I was accustomed to spending Saturday nights and Sundays with friends in the Palm Beach area, and while still pondering I took along a case that weekend and distributed samples among appreciative friends so they could help me meditate…On Monday morning, when I opened my garage, the liquor was all gone without a trace; I got an anonymous telephone call thanking me for taking care of it and offering a sure source of supply in the future. I got to know the anonymous caller pretty well with the passage of time.*

A1A (Ocean Boulevard)

A1A was originally called Ocean Boulevard because it ran along the ocean. After World War I ended in 1918, three elections were held to form a Special Road and Bridge District to finance the extension of Ocean Boulevard to Boca Raton.

In Boca Raton, the road was originally farther to the east, but in the early 1940s it was moved to its present position. Dr. Peter Barrett, who was about six years old at the time, lived in the Boca Raton Villas on A1A just across from Lake Boca Raton. He told this story about the repositioning of A1A, manpower courtesy of chain gangs:

U.S. Highway 1 looking south in the late 1940s. Note the lone traffic light and town hall to the right. *Photo courtesy of the Boca Raton Historical Society.*

We lived in Floresta for our first year in Florida, and then moved to the Villas when Grandma became very ill. She died May 19, 1940. The new road was built about that time, and the road gangs dug and shoveled for some time right at the front of our property. I recall ambling out to talk with them, curious about their interesting clothes…they were friendly, and on at least one occasion I had lunch with them, sitting on a wheelbarrow. But my parents let me know that they didn't approve of my new friends, and that was the end of that. The roadwork activity moved slowly along toward the south. No bulldozers or trucks. Just picks and shovels and men in striped clothes.

Federal Highway

One of the oldest and most well-known roads in the United States highway system is U.S. Highway 1 that runs from Maine to Key West, Florida, a distance of 2,390 miles. Yet it wasn't until Henry Ford introduced the Model T in 1908 that pressure was created on the federal government to become more directly involved in road development. When Congress passed the Federal-Aid Road Act of 1916, it created the Federal-Aid Highway Program. This program funded state highway agencies that would support road improvements, but World War I abruptly brought the program to a halt.

With the Roaring Twenties, the Bureau of Public Roads (BPR), operating as ORI (Office of Road Inquiry) within the Department of Agriculture, revived the program. This authorized the Federal Highway Act of 1921 to provide funding to help state highway agencies construct a paved system of two-lane interstate highways.

Through this program, the Federal Aid Highway, also known as Kings Highway, was built in Boca Raton in 1927. Eventually known simply as Federal Highway it was constructed of crushed rock. The Boca Raton portion was fifty-seven feet wide and ran 11,200 feet through the heart of town.

In 1948, the road was paved and widened to four lanes. But before that happened, Bill Robinson, a cadet training at the Boca Raton Resort & Club, told what it was like standing on this road in the pitch dark, trying to return to the Boca Raton Resort & Club after a night on the town in Miami during the early 1940s:

> *The stretch from Fort Lauderdale to Delray at night was one of virtual total darkness. I well remember missing the last bus out of Miami (the midnight bus) and having to hitchhike back to Boca. Since there was very stringent gas rationing, this was not easy to do.*
>
> *I remember standing literally for hours in total darkness and listening with considerable apprehension to the cries and calls of animals in the Everglades, which at that time extended virtually to the highway. Occasionally a pinpoint of light would appear down the highway. Most of the time it was a car stacked with G.I.s with room for not one more. Presently, it would be daybreak and not long after there would be cars coming up the highway heading for BRAAF. These would be, for the most part, civilian employees who commuted from the Ft. Lauderdale area. Thus, gratefully, I never missed Monday morning roll call.*

Camino Real

Designed by Addison Mizner in the 1920s, Camino Real was to be a 160-foot-wide boulevard. As the focal point of Boca Raton, plans called for the road to begin at the Ritz-Carlton (the original hotel designed for the beach) and end two and a half miles west at Ritz-Carlton Park, a golf course community.

The street, envisioned to cross over the Intracoastal Waterway by a Venetian-style bridge, included a three-story tower containing a bridge-keeper's apartment. Passing through the inn's golf courses, designs called for Camino Real to become the major shopping street of the new resort. Central to the resort was a canal modeled after Rio de Janeiro's famous Botafogo Canal, complete with gondolas.

Though never completed, the thoroughfare still stands as the widest street in Boca Raton. Lined with stately royal palms it remains the regal access road to the prestigious Boca Raton Resort & Club.

Glades Road

Glades Road, an east-west two-lane thoroughfare, gave farmers a straight shot from the western agricultural fields near the Everglades into town. Later when development pushed west, the road was widened.

I worked at Boca West during the initial widening and recently recorded an amusing incident:

This *Boca Raton News* photo taken April 17, 1977, shows Jerry Rich's car filled with beans from Bruschi Farms. *Photo courtesy of the Boca Raton Historical Society.*

In the late 1970s, Glades Road was in the throes of being widened. The new lanes constructed on the south side of the road were built several feet higher than the existing ones. One afternoon, a candy-red convertible driven by a Boca West teen stopped in front of the entrance to the development and waited to turn. At the time, the western portion of unincorporated Boca was still agriculturally rich with extensive bean fields.

A truck loaded with beans was traveling east when its brakes failed. To avoid hitting the convertible, the truck ran up onto the new dirt road. It then proceeded to tip over, dumping its entire load of beans into the open convertible. Fortunately, neither driver was hurt but I remember the laughter that ensued as loads of residents stood on the roadside taking in the humorous sight. Many enjoyed fresh beans with their steak that night.

Waterways and Bridges

Early farmers cultivating land west of the city needed a way across the north-south waterway known as the Hillsborough River, now called the El Rio Canal. To accommodate this need, the community built the first wood-plank bridge in 1905.

On the east side of town, residents required access to the beach over the East Coast Line Canal. Originally a shallow ribbon of water, it flowed between the mainland and the barrier islands at the Atlantic. *Agnes*, a small steamer, carried passengers from Jacksonville to Key West through this five-foot-deep, fifty-foot-wide waterway. It is known today as the Intracoastal Waterway.

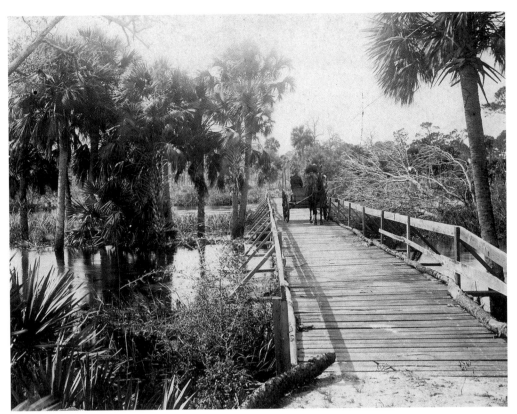

A horse-drawn wagon crosses Boca Raton's first bridge across the Hillsborough River to access farmland west of the city. The waterway is now the El Rio Canal. *Photo courtesy of the Boca Raton Historical Society.*

Lake Rogers, Lake Wyman and Lake Boca Raton are a part of this waterway, which flows south from Delray Beach. At the Boca Raton Resort & Club part of the water spills out into the Atlantic Ocean through the Boca Raton Inlet. The remainder flows south under the Camino Real Bridge toward Deerfield Beach as a continuation of the Intracoastal Waterway. Four key bridges span this waterway in Boca Raton.

Palmetto Park Bridge

Built as an extension of Palmetto Park Road in 1917, Palmetto Park Bridge became Boca Raton's first bridge to span the East Coast Line Canal. A single-lane wooden swing–type bridge, it was manually operated by a bridge-tender who was solely responsible for its operation and maintenance.

The first bridge-tender, Mr. Townsend, and his wife, Liza, lived in a "two-room wooden house built on pilings over the northeast end of the bridge," according to Diane Benedetto, daughter of H.D. Gates, whose family home was next to the bridge on the northwest side:

Sometimes in the clear stillness of the day I would hear the faint sound of a boat whistle blowing and my heart would beat with excitement as I shouted, "Boat coming. Boat coming." I would race off to the bridge and try to unanchor it, but mostly I just got in the way. Then I would try to help put the turnstile up and turn it. When the boat approached I would run to the side of the bridge and hang over the rail and yell, "Hi!" and wave as the boat passed through. There were not too many boats in those days. That was lucky as the bridge was a "Seven day wonder" [referring to the fact that the bridge-tender manned the bridge seven days a week].

The Townsends soon moved away and Lucas Douglas took over duties at the bridge. Benedetto recalled how the bridge served as the nerve center of the community:

Every night at the bridge there was a fire built and benches of timbers and logs set up around it. The older townspeople would sit there for a few hours after supper and recount the events of the day, the town gossip and news of the world as they knew it...Lucas Douglas was the source of all information and I used to think he was the wisest man I ever knew. He knew everything and everybody...His world there by the river was the center and heartbeat of Boca Raton.

In 1928 the turnstile bridge was replaced with a drawbridge and in the mid-1980s by a longer and higher drawbridge. Douglas manned the Palmetto Park Bridge until he retired in 1947. Because of his long servitude, local residents referred to the bridge as the "Douglas Bridge."

Boca Raton Inlet Bridge

In the early years, there was no Boca Raton Inlet, but residents soon realized that by dredging the settled sand they could gain access to the Atlantic. Soon thereafter, the first Boca Raton Inlet Bridge was erected.

Constructed in the early 1920s, the Boca Raton Inlet Bridge was a fixed wooden bridge that soon became a favorite gathering place for locals to fish, cool off in the evenings with the inland breeze or discuss the day's events. A drawbridge was added to the structure in 1930 and in 1964 the current bridge replaced it.

Haven Ashe served as bridge-tender at the Boca Raton Inlet Bridge from 1942 to 1964. He worked from 6:00 a.m. to 6:00 p.m., seven days a week, with few days off. On a busy day, one hundred boats passed through the inlet. While the bridge was the conventional type powered by electricity with gates that opened in the center, Ashe still had to laboriously close the gates by hand on either end of the bridge.

Located in the middle of the bridge, the bridge-tender's house enabled him to see approaching vessels, along with Old Joe, a large alligator. Stranded in the salt water of the Boca Inlet and the cove area of Deerfield Beach, Old Joe lived mostly in Deerfield Beach. Occasionally, however, he meandered up to the Boca Inlet, where he became a common sight to townsfolk.

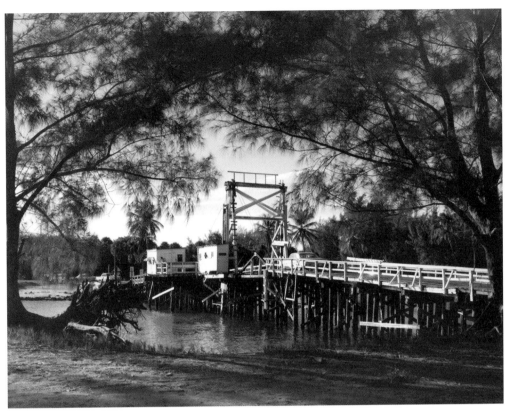

The Boca Raton Inlet Bridge in 1963—one year before it was replaced. *Photo courtesy of Dick Kitchen.*

As though on cue, a whistle brought Old Joe close to shore and residents threw him bread. Then, he turned around and swam back to his home in Deerfield. His travels always astounded new spectators because to their surprise, Old Joe was blind.

During World War II, the coast guard imposed tight security on the bridge, at times stopping boats to look for smuggled goods. When boats weren't coming through, Haven caught bait or made and sold catch-nets, as the bridge was often the chosen site of many a fisherman. Dave Ashe told of his father catching a world-record snook weighing forty-five pounds and later a world-record amberjack.

But the biggest fish story was told by Dr. Peter Barrett, who as a boy lived just north of the bridge on the ocean at the Boca Raton Villas. He remembers one adventure initiated by Dr. William Sanborn (for whom Sanborn Square is named). Sanborn, a retired dentist who wintered in his large home located just south of the Barretts, was an avid fisherman. Barrett recalled:

> One summer day, Doc Sanborn decided to fish in the inlet, which connected the ocean and Boca Raton Lake. He dropped his line into the water from the wooden bridge, which crossed it, and as he did so, he was surprised to see a huge "devil-fish," or giant manta ray, swimming lazily with the tidal surge toward the lake.

When Doc Sanborn first saw the giant manta ray, all of his sporting instincts were unleashed. Doc Sanborn knew that he had to catch him.

A plan was hatched. He would harpoon the monster from the bridge. In desperation, he contacted some of the army officers who were assigned to the training operation at the Boca Raton Club. The result was a spear with a single large barb on one end and a loop for a rope on the other end. The military officers were also helpful in finding a strong hawser, "liberated" from the PT boat dock near the Boca Raton Club.

Doc Sanborn attached one end of the hawser securely to a crossbeam of the bridge, coiled the rope at his feet and stood ready with harpoon in hand. A bespectacled, gray-haired gentleman of slight stature, he bore no resemblance at all to Captain Ahab in Herman Melville's Moby Dick, *and yet he shared the same single-mindedness in trying to capture his quarry.*

Right on time, the giant manta ray moved toward the bridge in the midst of the tidal flow boiling through the inlet, easily visible near the surface, with great black wings undulating slowly and rhythmically. Doc Sanborn stood ready, and as the manta ray passed under the bridge, he hurled the iron harpoon thirty feet down toward the back of the giant below. Doc Sanborn's aim was true, and the injured manta ray leaped completely out of the water and then crashed downward with a great splash. The hawser rope began to uncoil rapidly as the manta ray continued to swim with the tide toward the ocean.

As the uncoiling hawser rope neared its full length, the giant manta ray continued to swim out to sea with great speed. The rope then tightened, and Doc Sanborn and his friends prepared to haul the manta ray back to the bridge. But that was not to be. There was a loud cracking sound, and the crossbeam of the bridge to which the hawser had been attached suddenly gave way. The giant manta ray never slowed down. Out with the tide it went, into the ocean, with the harpoon pointing upwards to the sky, never to be seen again.

Camino Real Bridge

The original bridge at Camino Real was a pony-truss or swing bridge relocated by Geist in 1929 from the Hillsboro Canal in Deerfield Beach. After Geist's death in 1938, the county moved the old bridge to the western part of the county and a new bridge was constructed, courtesy of the Federal Emergency Administration of Public Works. Completed in 1939 and named the Clarence H. Geist Memorial Bridge, it included a one-story masonry structure for the bridge-tender.

Housed close to the bridge in 1943 were military troops occupying the Boca Raton Resort & Club. On one particular day they underwent a training exercise over the canal where a tragedy occurred. John Mangrum, a cadet stationed at the facility, told what happened:

They tied a great big rope across the canal and we were supposed to go across it in full combat gear. Just before I got ready to go, the piling the rope was tied to toppled and all the men went into the canal. Several of us jumped in to help get them out. Everyone got

out except one black cadet who drowned. No one had bothered to find out that he couldn't swim. They found his body the next day on the beach.

In 1984 a new concrete two-story tower with somewhat smaller floor space replaced the original bridge-tender's house. Outside the newer structure, a spiral stairway wound its way to the observation room at the top of the building. Wooden plank walkways are still part of the bridge.

Over the years, discussions emerged on replacement of the bridge, but it continues to stand today as evidence of an earlier Boca Raton.

Spanish River Bridge

While the other three bridges have a long and interesting history, that cannot be said of the Spanish River Bridge. Built in the late 1960s, cost of construction was estimated at $750,000 and came from primary road funds because the structure would connect U.S. Highway 1 to A1A. When it finally opened, residents were thrilled to access the beach and Spanish River Park from a more direct route.

CHOO-CHOOS

As mentioned in chapter two, after the primitive roadways, railroads became the second mode of land transportation through Boca Raton. As such, they played a vital role in bringing residents and visitors to the small coastal town, transporting produce to market and delivering building materials to support the town's growth.

Florida East Coast (FEC) Railway

One of the oldest surviving railroads in America, Henry Flagler's Florida East Coast Railway is a large regional line that serves the east coast of Florida. Its tracks run between Miami and Jacksonville, Florida, where it interchanges with its main railroading partner, Norfolk Southern, and to a lesser extent with CSX Transportation.

When the train first traveled into Boca Raton no depot existed. A loading dock attached to Rickards's packinghouse that stood alongside the tracks acted as a means of transfer for passengers, produce and cargo. In the October 1975 edition of the *Spanish River Papers,* Diane Benedetto recalled what the train was like in the 1920s:

The only way to get to our town was by train and you never knew where you might be let off, baggage and all. The train just slowed down and you jumped off with your luggage thrown off after you. You got it home the best you could. It wasn't much fun hauling a trunk across the hot sand in ninety degree weather, but that was it or leave it there. The same train brought the mail and they would snatch the mailbag off the post and throw our mail in a bag out the door to the ground.

Florida East Coast Railroad stops at Boca Raton. *Photo courtesy of the Boca Raton Historical Society.*

The train depot stood on the east side of the railroad tracks off Palmetto track to a little office where there was a wireless and a mail post. We used to play there, sitting on the bales of hay watching the trains go by. That was one of the few exciting moments of the day. We would see the people in the coaches heading for Miami and yearned to share such an adventure. One day we finally did and it wasn't as much fun as it looked. The coaches were hot and you were covered with cinders that would get into your eyes and they were not easy to get out.

Following the purchase of the Cloister Inn, Clarence Geist realized the town needed a train depot to adequately facilitate the arrival and departure of hotel guests. Negotiating

with the FEC Railway, he offered to finance the building so long as they agreed to build it in accordance with the Mediterranean style of the club. Agreeing to these conditions, the station was completed in 1930.

In *Boca Raton: A Pictorial History*, authors Donald W. Curl and John P. Johnston noted: "Most of the club staff, many town residents, and the club orchestra regularly came to the station to greet Geist's yearly arrival."

Passenger service was discontinued in the 1960s and the station fell into disrepair. Desiring to preserve the landmark, the Boca Raton Historical Society purchased the building and with funding from grants and a generous gift from Countess de Hoernle, the facility was restored in the 1980s. Named the FEC Railway Station, Count de Hoernle Pavilion, it now serves as a community center

What Flagler built through the small community of Boca Raton back in 1895 is projected to serve the city's growing population well into the twenty-first century. Long-range plans call for moving or adding Tri-Rail passenger service to the Florida East Coast rail corridor, which runs next to U.S. Highway 1 (Biscayne Boulevard in Miami-Dade County) and Federal Highway (Broward and Palm Beach Counties). This will deliver tri-county workers into the heart of the cities and give them better access to their place of employment.

Seaboard Air Line and the Orange Blossom Special

The consolidation of the Seaboard and Roanoke Railroad and other lines in the Carolinas into a single system in the 1880s birthed the Seaboard Air Line (SAL) Railway. Starting in New York, it eventually ran to West Palm Beach, Florida. But it wasn't until 1929 that the Orange Blossom Special, the railroad's newest marketing campaign for overnight travelers, pushed its way south to Miami.

Seaboard Air Line tracks paralleled those of the FEC several miles west of Boca Raton where a small wooden platform received passengers. With Boca Raton being only a blip on the southeast coast of Florida, no formal depot was built.

During the war, the platform saw much use as troops traveled from the Western United States to the Boca Raton Army Air Field via the Seaboard Air Line and disembarked there. In January of 1943, three graduating nurses—Bernice Butler, Gladys Gillis and Anna Lee Hooten—made their way south to the Boca Raton Army Air Field from the University of Tennessee. Gillis recalled they arrived at night and it was so dark that an officer traveling with them had to use his lighter to locate the phone to call for transportation to the base.

When automobiles became the preferred method of travel, passenger service stopped and the railroad was used strictly for commercial purposes.

Tri-Rail

With the inconvenience of widening both I-95 and Florida's Turnpike in Palm Beach, Broward and Dade Counties in 1987, the Florida Department of Transportation

created Tri-Rail, a temporary commuter rail service to help transport Florida workers to their jobs. The temporary mode, however, soon became permanent and the Department of Transportation added more trains and stations.

The seventy-two-mile system, with eighteen stations along the south Florida coast, shares its track with Amtrak's *Silver Meteor* and *Silver Star* and CSX's Miami Subdivision. It is run by the South Florida Regional Transportation Authority.

Opened in 1989, the old Boca Raton station (no longer extant) stood on Northwest Fifty-third Street, north of Yamato Road and east of Congress. Following a thirteen-day disruption of service caused by Hurricane Wilma, the new Boca Raton Station opened on November 4, 2005. It sits on the south side of Yamato Road, just east of Congress Avenue and west of I-95.

BUSES

Bus service in Boca Raton began in the 1930s and operated out of the Colonial Stages Bus Station located at the Boca Raton Sundry Store, the site of Brown's Bar and Restaurant. The buses carried passengers on local excursions to Miami or West Palm Beach for shopping and transported visitors into and out of Boca Raton.

During the war, when gasoline and tire rationing was at its height, bus service was the lifeblood of the military community as troops traveled to Fort Lauderdale, Miami, Delray Beach and West Palm Beach to access shopping and nightlife when off duty.

BOCA RATON MUNICIPAL AIRPORT

In 1933 the Florida legislature named A.B. McMullen, a pioneer Florida flier, director of an aviation division within the State Road Department. His job was to develop the air industry in Florida. In a ten-year plan, McMullen targeted Boca Raton as an area in need of an airport. Donald Curl, author of *Palm Beach County*, explained McMullen's rationale for selecting Boca Raton. "The terrain afforded no natural areas for emergency landings, which were fairly common for the planes of that era."

With the expansion of the Boca Raton Resort & Club, many of Geist's guests, who now owned airplanes, needed a convenient way to travel to and from Boca Raton. Recognizing an opportunity to combine construction of the airport with the national government's emergency relief activities, McMullen urged Geist to ask the town to build an airport.

Gordon B. Anderson, Boca Raton Resort & Club general manager, organized and planned the project. The Model Land Company offered land decried worthless for agricultural purposes and the New Deal Works Progress Administration (WPA) granted $38,537 for the project. The town contributed $11,869. Construction began in late 1936 with the grass runways completed in 1937.

An aerial view of Boca Raton's first airport, completed in 1937. *Photo courtesy of the Boca Raton Historical Society.*

The arrival of the Boca Raton Army Air Field required that the airport be expanded into a monstrous airfield (see chapter six). It became the site of many crashes. Veteran pilot Manny Chavez was an eyewitness to several of these:

> *The B-24 pilot was an experienced combat pilot who had just returned from Europe. The B-17 was taxiing up the northwest segment for takeoff to the east and the B-24 was headed up the southwest runway, also for the east takeoff. The uncompromising rule is that when you reach the takeoff position, you stop and read the final checklist out loud so the other can hear it. Then you check your compass heading to confirm that you are on the correct runway.*

The B-24 hotshot combat pilot made a running turn to the takeoff runway, but instead of getting on the east runway, he got on the southeast runway and locked wings with the B-17 about 1,000 feet down the runway. I was on the ramp in front of Operations and it was a spectacular crash, shearing the cockpit off the B-24 and breaking the B-17 in two. I saw one of the pilots run a 100-yard dash away from the crash with a parachute strapped to his back.

After the war, Mayor Mitchell notified the War Assets Administration (WAA), the Civil Aeronautics Administration (CAA) and the U.S. Army Corps of Engineers that the town wanted the base and the Boca Raton Field "in its entirety" for its own municipal airport.

"Control of the airport then passed through five different government agencies before the Airport Authority was developed to take control of the airport," stated the Boca Raton Municipal Airport website.

The Boca Raton Municipal Airport currently uses one of the original airstrips from the former Boca Raton Army Air Field. The airport is publicly owned and designated as a general aviation transport facility; a staff of six manages it. A seven-member authority, appointed by the City of Boca Raton and Palm Beach County Commission, governs the facility.

Abodes and Buildings

Boca Raton's First Home

When Thomas Moore Rickards settled in Boca Raton, he built the town's first home southeast of the present-day Palmetto Park Bridge. Overlooking the East Coast Line Canal, it was a two-story wooden structure with a large front porch that ran the length of the building.

Rickards also built Boca Raton's first commercial structure, the FEC packinghouse east of the FEC tracks on Dixie Highway. It was used to process citrus. In 1902 Rickards built himself a second home, later purchased by George Long when Rickards left Boca Raton in 1906. Long also purchased the packinghouse, renaming it Long's Packing House. The structure hosted community gatherings, including Board of Trade meetings, elections and social events. It also housed Boca Raton's first school.

Boca Raton's Oldest Standing Homes

Built by Burt and Annie Raulerson in 1914, one of Boca Raton's oldest homes originally stood on Palmetto Park Road west of the FEC tracks. Like the rest of the early pioneers, Mr. Raulerson was a farmer. Diane Benedetto remembered his property: "His farms were west of town and we children used to love to go out there. It was different from our place. There were endless fields of beans, peppers, eggplants,

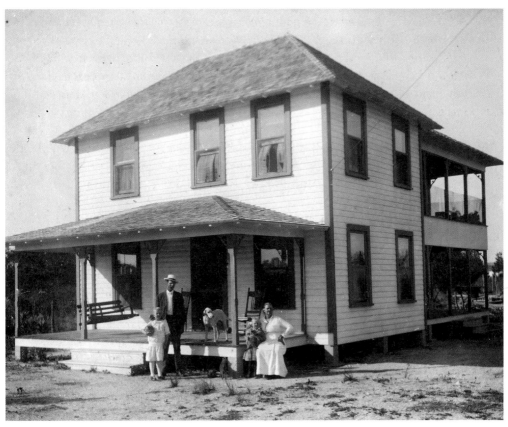

Bert and Annie Raulerson, with daughter Ivy, arrived in 1903 and built this house in 1914. *Photo courtesy of the Boca Raton Historical Society.*

cucumbers and so forth. Our place looked more like a garden in comparison, as we grew only small patches of vegetables."

In the late 1930s, Gladys White rented the home and turned it into a rooming house. When the Boca Raton Army Air Field moved into the area in 1942 and housing became a premium, the government leased the structure to house the Women's Army Auxiliary Corps (WAACS).

It became the "Half-way Rooming House" after the war but when troops left in 1947 the house fell into disrepair. Condemned in 1987, Diane DeMarco purchased the home, moved it to 290 Southwest Third Street and completely restored it. Commercial businesses rented the structure until 2006 when the Children's Museum purchased the home with intentions of adding it to the museum complex. Known today as the Boca Raton Children's Museum, Singing Pines actually began as the home of William and Mamie Myrick back in 1913. Originally from North Carolina, the Myricks purchased the land from the Model Land Company. Commercial businesses rented the structure until 2006. In early 2007, negotiations were underway for the donated home to become part of the Children's Museum complex.

In 1917 the Myricks sold the house to New Yorker George Washington Race, who moved to Boca Raton with his wife, Nellie, and daughter, Lillian. Lillian named the home Singing Pines because the tall pines surrounding it caught the breeze and played a melody.

When Mr. Race died, Lillian made ends meet by renting out rooms in the two-bedroom cottage. Though she kept a private room for her ill mother until her death, to make extra rooms Lillian put up cardboard partitions throughout her home or strung clothesline down the center of the rooms and hung sheets over them.

In 1976, ill and nearly destitute, Lillian sold her land and moved to a nursing home. She donated her beloved Singing Pines to the Boca Raton Historical Society. They moved it to its present location on Second Avenue, where it became the Boca Raton Children's Museum.

Spanish Village and Floresta

In October 1925, Addison Mizner's development company announced it would construct houses in two subdivisions west of town—Spanish Village and Floresta. Of Spanish Village, the Boca Raton Historical Society website stated:

> Originally designed as modest working class cottages by the Mizner Development Corporation, twelve true Mizner-designed 1920s era homes survive in Spanish Village, a subdivision located north of City Hall off Boca Raton Boulevard on Northwest Seventh and Eight Streets. Despite efforts by some of the homeowners, these buildings are not currently protected by designation.

In Floresta, the houses were planned for executives and directors of the Mizner Development Company. The Boca Raton Historical Society website describes the architecture of the homes:

> The Old Floresta houses had plain facades—Mizner said that simplicity "[was] always dominant in the best of Spanish architecture"—of rough-finished stucco with numerous windows and doors that frequently opened onto wrought-iron balconies. He also designed the street front facades with thick walls to give the windows and doors deep reveals. The roofs, covered with barrel tiles made at Mizner Industries, were uneven with low-pitched lines alternating with flat parapets. In many of the smaller Old Floresta houses, Mizner substituted dining alcoves for formal dining rooms.

The Robinson Company, a large New York contractor building the Cloister Inn, constructed twenty-nine homes in Floresta. When the building boom went bust, the original landowners repossessed the land and the houses. The neighborhood later became unified through landscaping and botanical street names such as Oleander and Hibiscus.

Today, none of the Mizner homes exist in their original design as all received additions, most within the past ten years. However, the neighborhood is designated a historic district and having an address there is still very desirable.

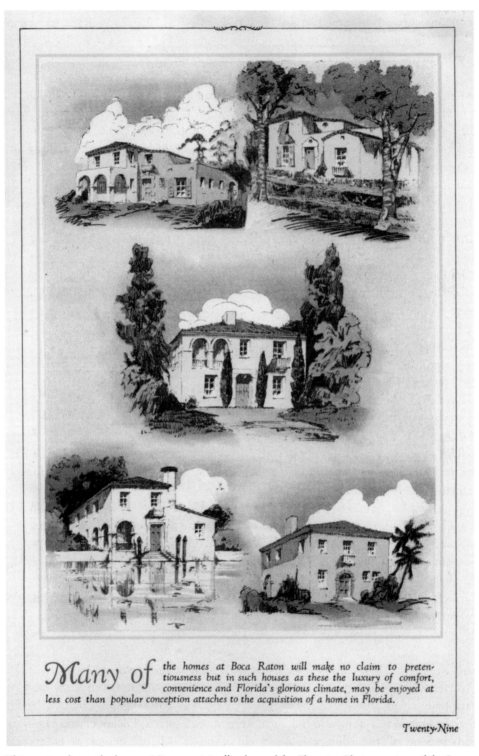

Many of the homes at Boca Raton will make no claim to pretentiousness but in such houses as these the luxury of comfort, convenience and Florida's glorious climate, may be enjoyed at less cost than popular conception attaches to the acquisition of a home in Florida.

Twenty-Nine

This poster shows the houses Mizner originally planned for Floresta. *Photo courtesy of the Boca Raton Historical Society.*

Homes in Pearl City

Black landowner Alex Hughes built the first house in Pearl City in 1927. The initial dwellings, with just a couple of rooms, weren't very substantial. Described by early residents as "shacks," living conditions were cramped. When more room was needed, the family simply added on.

Women cooked on wooden stoves but some residents had outside sheds and smokehouses. Perishables were kept in an icebox and George the iceman made regular rounds, lopping off twenty-five- to fifty-pound chunks of ice. Toilets were of the outside variety and water was hand pumped. With no sink, families washed their dirty dishes in a dishpan and took turns taking baths in a large tin tub. In some houses electricity didn't arrive until 1942.

Dixie Manor and Beyond

Hemmed in by Federal Highway and the rezoning of some Pearl City land on the east for commercial purposes, the FEC to the west and white commercial establishments to the south, the only area available for expansion of the black population was to the north.

At the beginning of the war, the Federal Public Housing Authority (FPHA) built two projects to house military families—one for whites called Palmetto Park, located on Palmetto Park Road, and one for blacks called Dixie Plaza. Located just north of Pearl City on the northeast corner of Glades Road and Dixie Highway, Dixie Plaza consisted of a series of small individual concrete block homes. The neighborhood is known today as Dixie Manor. Another black community built north of Dixie Manor became known as Fifteenth Terrace.

With prices for apartments and single-family homes for whites rising in the area of Northeast Twentieth street, in the 1950s and 1960s concern arose from white landowners that there was no natural barrier—canal or roadway—to separate blacks from the white community. This led to the construction of an eight-foot concrete wall. While it failed to comply with zoning restrictions regarding the construction of walls and fences, it was allowed to remain and can be still be seen today.

Towering condominiums and massive residential homes have replaced the homes of an earlier Boca Raton. However, families in the twenty-first century have much in common with those of yesteryear—their home is still their castle.

BLACKBOARDS AND STETHOSCOPES

EDUCATION IN BOCA RATON

Boca Raton's First White School

The children rose early. Following a hearty breakfast, they picked up their lunch pails and headed south down the crushed rock road. At the end of their thirty-minute walk they stepped into the one-room schoolhouse at Deerfield Beach where they spent their day learning the three Rs—reading, 'riting and 'rithmetic.

When the school day was over, the children retraced their steps back over the Hillsboro Canal to Boca Raton. But on this particular day, an early afternoon thunderstorm soaked the boys and girls before they could reach the safety of their homes.

The four-mile trek to and from school was taking its toll on the children and the small Boca Raton community soon realized it needed a school that was closer—one that was in its own backyard. With that in mind, community leaders George Long, Frank Chesebro and Bert Raulerson spearheaded efforts to bring the first white school to Boca Raton. Coupled with a promise from the county that it would supply a teacher if the town built the school, Chesebro cleared land and the town donated building materials and labor.

While waiting for the new structure to be completed, in 1908 the children eagerly gathered in a room in Long's packinghouse. This makeshift location was the beginning of public education in Boca Raton.

With the completion of the new school, the children moved to the one-room wood-framed schoolhouse tucked back in the sand and scrub oak. There, grades one through eight learned their ABCs in the cozy whitewashed structure.

A succession of teachers followed, most staying only one year. But in 1914, a young eighteen-year-old Laurence Gould arrived to serve the town. For the next two years, he

Children walk through scrub oak to attend the one-room schoolhouse. *Photo courtesy of the Boca Raton Historical Society.*

drove a covered wagon to pick up fewer than two dozen children for school. He was later tapped to assist Rear Admiral Richard E. Byrd in his exploration of Antarctica in 1928–29. He received the Congressional Gold Medal and more than thirty honorary doctoral degrees.

As the population of Boca Raton grew, the little schoolhouse soon bulged at the seams. Once again, George Long rose to the challenge and spearheaded efforts to erect a larger building. In 1920 at the corner of Southwest First Avenue, where the Boca Raton Elementary School is now located, Boca Raton School opened its doors to students and became the first public building in Boca Raton. A Spanish-style masonry structure, the school served students from first through eighth grades in four classrooms.

A second structure was later added to the school that served both as an auditorium and a gym. Called a "gymatorium," it quickly became the focal point of the school and was used as the community center. Residents enjoyed celebrations, civic activities, dances and pageants in the building.

Joyce and Gloria Brown attended the small school in 1941. Joyce recalled a most important occurrence that happened on Monday, December 8: "Belle Collar [the principal] called all the teachers and students into the new auditorium to announce the beginning of World War II. I was frightened and not sure what that meant for children and parents. We were encouraged to find scrap metal for the war effort and were even let out of school to scour the woods for metal."

During World War II, USO dances were held in the gymatorium to entertain troops stationed at the Boca Raton Army Air Field.

In 2002, Pat Jakubek, Arlene Owens, Diane Borchardt and Linda Jackson, members of the Pioneer Club, spearheaded efforts to preserve the landmark from demolition. Jakubek said they were dubbed "the Crazy Ladies" and immersed themselves in trying to save the endearing structure:

> *When the word went out that our beloved auditorium was going to be knocked down the group that tried to save it went into overdrive—over emotion. We worked so hard to save it, raised money, held meetings, wrote letters, attended every function going on in town, badgered the City Council, School Board, Superintendent, etc. We were trying to save a dearly loved building, an old friend, a piece of the history in BR, and a piece of our lives and hearts. Emotions ran high!*
>
> *As we met people out in the community, everyone wanted to talk about their tie to the building, their memories, their teachers. So I began recording what they said, starting with napkins and little pieces of paper to jot down the words. Then I started carrying a notepad and pen everywhere I went. Then I began contacting people on the phone and on the Internet. Everything that was remembered was too valuable to sail off into the ethers; I felt they needed to be recorded.*

Able to raise only a small portion of the $500,000 needed and having exhausted all available deadlines and resources, the group was saddened to see the building torn down.

As students entered high school, they were bused to Delray Beach, where they attended Seacrest High School, now Atlantic High School. Longtime Boca Raton resident Arlene Owens tells of heartfelt disappointment in 1963 involving her senior prom:

> *I had waited and waited to go to a prom and they were always held at the Boca Raton Hotel & Club* [sic]. *It was my senior year, I broke up with my boyfriend and my male friend broke up with his girlfriend so we went together. We were told we couldn't have it at the hotel because there were two black kids in our school and blacks weren't allowed in the hotel. The blacks weren't even going to go the prom but that didn't matter. So we had it at the Cabana Club.*

Even though Boca Raton had a burgeoning black population, until the 1960s Boca Raton schools remained segregated.

Boca's First Colored School

Early accounts of education for "colored" children noted it began in the all-black Macedonia Chapel AME Church in Pearl City. Alex Hughes, one of the founders of the church and Pearl City's first resident, was instrumental in the school's formation.

In 1920, around the time the new Boca Raton Elementary School was about to open, an entry in Frank Chesebro's diary stated he spent eighteen days moving "the school" (the original one-room schoolhouse for white children) across the tracks to Pearl City. The school was called Boca Raton Negro School and educated students from first through eighth grades.

The children learned their lessons from well-worn hand-me-down textbooks, some with torn and missing pages, donated by the white school. In *Pearl City, Florida* a resident stated, "We were always behind the white schools, of course. Some of our black teachers were only high school graduates. There was deep segregation at that time."

As in most one-room schools that housed students of varying grades, the older children helped teach the younger ones. At one time, fifty-two children were under the tutelage of Mrs. Ashley, who organized the grade levels by rows. Irene Carswell and Lois Martin shared their thoughts: "Mrs. Ashley would have an older kid in the higher grades to listen to the younger ones. She would give them work, like addition: one and one is two, et cetera. And then she would do the other classes…It was hard teaching back in those days. She was teaching everybody, so everybody would help each other."

Discipline, in the form of spankings using a palmetto rod, was meted out to keep the children in line.

In the late 1930s, the old wooden school was replaced with a more substantial structure built on a site where Glades Road is now. During this time, agriculture was still a very large industry in Boca Raton and getting the children to go to school proved difficult as many of them worked in the fields picking vegetables alongside their parents. Lois Martin remembered:

You didn't have laws going then. If parents just didn't feel like sending the kids they didn't have to send them. Nobody forced you to send them, which means that you had some parents whose kid might go to school two days out of the week and pick beans three. When I was in the eighth grade I guess there were about sixteen of us, and by the end of the eighth grade year there were only two of us left. Everybody else had dropped out. There were only two of us who graduated. Me and this girl. Her name was Annabelle Clark. Farm kids would come here until twelve o'clock and a truck from the farm would come pick them up and they pick beans until evening.

Pearl City residents remember that the Butts farm had a school on the property for farm children:

Originally the kids on Butts Farm had an elementary school on the farm. There were two teachers, one of them lived out there, the other went and come. The school wasn't large, about three times as big as a room. During the harvest, the kids would go to school, then in the afternoon they would go to the bean fields. Later they closed that school and of course they were bused into Pearl City.

In the early 1940s, Mrs. Jessie Barrett, a white resident, taught first through third grades at the all-white Boca Raton Elementary School. On one occasion, she visited the Pearl City school at the invitation of its teacher. Martha Barrett Bell, her daughter, tells of her mother's experience:

She was impressed and touched by her work. It was a one-room school, but there was a second room where the teacher lived. There was a wood stove positioned so that it would heat both rooms. The teacher always had her door open and part of her teaching was demonstrating how one made their bed, cooked their food, cleaned, and washed clothes and dishes. Her room was a demo for the children, in addition to the regular teaching from Florida State textbooks.

With the advent of integration in the early 1960s, Boca Raton Negro School was renamed Roadman School after white councilman Frank Roadman. However, the school remained segregated.

Like the whites, black students trekked to Delray Beach to attend Carver Middle School or Carver High School, all-black schools. As the buses were not integrated, blacks had to walk, ride their bikes or find other methods of transportation if they wanted to continue their studies. Some dedicated students chose to live with families in Delray Beach so the commute would not be a hardship.

Coming Together

After decades without a high school, in the fall of 1963 Boca Raton Community High School opened its doors to become the first integrated school in Boca Raton. Also in that

Black students attended classes at Roadman School. It stood on Glades Road just north of Pearl City. *Photo courtesy of the Boca Raton Historical Society.*

year, the Palm Beach County Board of Public Instruction desegregated all schools and Roadman students were split between Boca Raton Elementary School and J.C. Mitchell Elementary School, Boca's second elementary school that opened in 1958.

Junior and senior high school students were given "'free choice' to attend previously all-white or all-Negro schools nearest their home." Nevertheless, race remained an issue.

Boca Raton's First Civil Rights Celebration March and Race Riot

Boca Raton had its first civil rights march on Thursday, March 25, 1965, when students from Marymount College (now Lynn University) organized a "celebration march." Sympathetic to the arrival in Montgomery, Alabama, of the march led from Selma, Alabama, by Dr. Martin Luther King, about two hundred civil rights workers from Miami to West Palm Beach participated in the march that ended at Ebenezer Baptist Church in Pearl City.

All remained quiet in Boca Raton until October 19, 1971, when at 12:45 p.m. "riot police were dispatched to Boca Raton High School for a full-scale battle," stated the local press. According to the article:

Apparently, black students had several grievances regarding unfair treatment of athletes and percentages of black students in extra-curricular activities, such as cheerleading, and the pom squad, and were attempting to discuss the issues with Principal Daniels and the faculty. Many were dissatisfied with Coach Joe Pribil's policies towards black football players on the team, and claimed he did not play them as often as he did the white players.

Some black students began attacking white students in the bathroom and several were treated at Boca Raton Hospital for abrasions, contusions and lacerations, but there were no reports of stabbings. One local doctor reported treating a student in his office, for a knife wound to the arm.

Today's Public Education

Boca Raton's public education has come a long way since 1908 and the little one-room schoolhouse. Today, twenty-one schools dot Greater Boca Raton—twelve elementary schools, five middle schools and four high schools.

In 2004 two of the newest schools opened—Don Estridge High-Tech Middle School and West Boca Raton Community High School. The Don Estridge High-Tech Middle School, named after the late Don Estridge whose brilliant team was responsible for giving the world the first IBM PC, immerses students in rigorous technology-infused learning. The West Boca Raton Community High School offers four specialized academies—drafting and design, information technology, culinary arts and medical sciences.

PRIVATE, FAITH-BASED, CHARTER AND OTHER SCHOOLS

Beginning in 1960, faith-based schools began to emerge in Boca Raton. Saint Joan of Arc established the first school on September 19, 1960, in a warehouse on Twentieth Street. There, seventy students in grades one to four attended classes with books and desks borrowed from a Catholic school in Miami.

In the spring of 1961, the church began construction of its own school facility and on September 5, 1961, students occupied its classrooms for the first time. Teaching the 250 students, grades one to eight, were four sisters and three lay teachers.

As Boca Raton's population grew, other faith-based and private schools soon laid down roots. Other earlier schools included Saint Andrew's School, chartered by the Episcopal School Foundation in 1962; Boca Raton Christian School, founded in 1973 as a ministry of the Boca Raton Community Church; and the Donna Klein Jewish Academy, established in 1979.

With the addition of charter schools, today Boca Raton is home to thirty-five primary and secondary non-public school campuses, serving thousands of students.

Students from the Boca Raton Chinese School entertain their audience with the Dragon Dance, one of the dances held in celebration of the Chinese New Year. *Photo courtesy of Laurence W. Stewart.*

Boca Raton Chinese School

In 1985 Olympic Heights Community High School in west Boca Raton became home to the Boca Raton Chinese School. Every Saturday morning, over one hundred students attend Chinese academic and cultural classes.

The Boca Raton Chinese School is an extension of the Chinese Cultural Association of South Florida (CCASF), the oldest and largest community-based organization serving Chinese Americans in Palm Beach County. Founded in 2001, the CCASF is a nonprofit, non-partisan organization dedicated to providing cultural, educational, recreational and other programs to promote Chinese cultural heritage to the south Florida community.

The school is open to all who wish to learn Chinese language and culture. Classes are held in reading, writing and conversational Chinese in the Mandarin dialect. Dance and other arts are a big part of the curriculum.

The Harid Conservatory

The Harid Conservatory was established in 1987 to provide high school students a dedicated dance curriculum along with its academic studies within a fully supervised

Female students study in the library at Marymount College. Once an all women's school, it is now Lynn University. *Photo courtesy of Lynn University.*

boarding school environment. A music curriculum was added in 1991 but was transferred to Lynn University in 1999.

An accredited institutional member of the National Association of Schools of Dance, the Harid Conservatory is recognized as a high school by the State of Florida. As part of their four-year curriculum, students attend Spanish River Community High School in Boca Raton for their academic studies and Harid for their comprehensive ballet training and related dance courses. Graduates receive a high school diploma and, for those who qualify, a Harid Conservatory Certificate of Completion.

HIGHER EDUCATION

Lynn University

A 123-acre campus with seven freshwater lakes is home to Boca Raton's first institution of higher education. Known originally as Marymount College (now Lynn University), it opened in 1962 as a women's junior college, founded by the religious order of the Sacred Heart of Mary.

In 1971 the school fell under the jurisdiction of Wilmington College of New Castle, Delaware, and was renamed the College of Boca Raton. Dr. Donald E. Ross became its president and in 1974 the college added third and fourth years to its program. In 1986 it was awarded Southern Association of Colleges and Schools (SACS) accreditation at Level II, and in 1988 received Level III accreditation.

The College of Boca Raton officially became Lynn University in 1991 in tribute to its benefactors, Eugene M. and Christine E. Lynn, and to reflect the growth of its programs.

Florida Atlantic University opened in 1964 with fewer than nine hundred students. *Photo courtesy of Florida Atlantic University.*

Today Lynn University is a private coeducational institution offering associate's, bachelor's, master's and doctoral degrees. Students come from more than forty-six states and ninety countries and have the opportunity to study abroad in a variety of educational settings.

Florida Atlantic University (FAU)

The closing of the Boca Raton Army Air Base became an educational opportunity for Boca Raton when, in 1955, the Florida Legislature authorized establishment of Florida's fifth public university in the southeastern section of the state.

On December 8, 1962, Governor Bryant officiated a groundbreaking ceremony attended by over two thousand residents and dignitaries. Vin Mannix, in a December 16, 1979 *Boca Raton News* article, "Etcetera by Mannix and the News," wrote, "The ground was broken for FAU in December 1962, and what was once a bastion of winged military might became an institution of high learning in 1964."

The campus officially opened on September 14, 1964, with fewer than nine hundred students, becoming the first university in the nation to offer only upper-division and graduate work. On October 25, 1964, with over fifteen thousand in attendance, U.S. President Lyndon Baines Johnson dedicated the university and accepted the first honorary doctorate awarded by Florida Atlantic University.

Among the first students to attend FAU in 1964 was Armand Grossman, a resident of Boca Raton. To illustrate the proverbial pranks of college students as well as the difference between "season" and "out of season" in Boca Raton during the 1960s, he told this story:

It was the summer of 1965. There was a beach bar at the corner at Palmetto and A1A called The Keg where I worked as a bartender. One afternoon a bunch of college guys from FAU who had been drinking beer decided to have a contest to see who could lay down in the road on A1A the longest before a car came along. The fellow who won was Danny Gibson, a local guy from Delray. He stayed in the road thirty-two minutes.

FAU has grown steadily since the mid-1960s when it first opened its doors. Today, it is a four-year educational institution that spans seven campuses—Boca Raton, Davie, Fort Lauderdale Downtown, John D. MacArthur, Treasure Coast, Sea Tech, Fort Lauderdale Commercial and Off-Campus. Serving an enrollment of over 25,000 graduate and undergraduate students, the university has eight colleges offering seventy-six undergraduate majors along with sixty-eight master's programs and doctoral degrees.

Palm Beach Community College

In 1971 Palm Beach Community College (PBCC) established a Boca Raton campus on the grounds of Florida Atlantic University. This allowed students the unique opportunity to earn a baccalaureate degree at one location.

Classes serve students seeking a college degree as well as those interested in job training, upgrading their skills and personal enrichment workshops. Students attend classes in state-of-the-art classrooms and laboratory facilities with full use privileges at the Florida Atlantic University library. In addition to courses for degree-seeking students, PBCC also offers adults of all ages a non-credit enrichment program.

STETHOSCOPES

When Johnny stepped on a rusty nail in early pioneer days, there were neither medical facilities nor trained medical personnel in Boca Raton to give him a tetanus shot. Diane Benedetto recalled in her written memories entitled "Early Days":

We had our fox fire remedies and cures for about any ailment. For a cold, sore throat, galloping consumption, you would mash up onions and kerosene, put them in a cloth and tie them around your neck. It was also put on your chest. A spoonful of turpentine in water was a sure thing to cure worms. When I cut my big toe almost in half on an axe, mother and Bessie Douglas washed it out with lye soap, then wrapped it in an old rag. It healed in no time at all. No infections and we seldom had use for a doctor...

If we stepped on a nail or cut our foot, we would put a poultice of salt pork or bread and milk then wrapped it in a rag. I don't remember anyone dying from infection. We didn't die easy. Mud packs were good for bee stings and insect bites. There were not any antibiotics in those days and we seemed healthier than people are today.

Both white and black residents in need of medical services or hospitalization traveled south to Deerfield Beach, Pompano Beach and Fort Lauderdale or north to Delray Beach and West Palm Beach. It wasn't until the mid-1940s that the community got its first permanent physician.

For the most part, residents of Pearl City and Yamato didn't go to doctors either. Annie Hughes acted as the resident holistic healer and could do "pretty much anything for a person." Herbs and home remedies were the order of the day. Christian leaves would draw out the fever and for tetanus, "all you did back then was beat the blood out of him a little, put a penny on that, and some fat back, and it will draw it right out. It will turn that meat greenish looking, and you live." Three sixes, a quinine concoction and a remedy called Father John cured colds.

In *Pearl City, Florida*, Lois Martin stated:

> *You had to be almost dead to go to a doctor. You see, what people die on now we lived on then. See, my image of medicine you buy today, I think it is killing a lot of people. We never did have tetanus shots and all of that. God took care of us. As it was you just didn't believe in spending too much money on a doctor. For one thing, it was so hard to see one, and plenty of times you had to stay on the outside. You didn't have any waiting rooms, and by the time you got in, you are already well. God was just good to us, because we didn't have plenty of sickness.*

If blacks needed a hospital, they went to the all-black Pine Ridge Hospital in Palm Beach, as blacks were not welcomed in the all-white hospitals. Babies, no matter what color, were delivered with the aid of midwives like Mary Jenkins from Delray Beach, who would come to the house and stay until the baby was born.

Shirley Rose Brenk Hood, daughter of Jensine and Tony Brenk, owners of Brenk's Grocery, tells how she entered this world in 1935: "I was born at home, above the grocery store. My mother worked in the store until noon and came up for lunch. We usually had Christian Science midwives to deliver the babies but I came so fast Laura Melberry, our black maid, helped deliver me."

Boca Raton's First Physician

William G. O'Donnell, a graduate of Georgetown Medical School, became the town's first physician in 1938. From 1938 until 1942, he and his wife, Dorothy, lived at the club, where he spent five months each year as its seasonal doctor.

After serving during World War II as commanding officer of the Fourth Auxiliary Surgical Group in General Patton's Third Army, he returned to Boca Raton in 1946. Opening a private practice, he became Boca Raton's first permanent physician. He later served as mayor from 1950 to 1951.

Since O'Donnell opened his doors and accepted the first Boca Raton patient, hundreds of physicians have established practices in the prestigious community. One of the first to follow in O'Donnell's footsteps was Dr. Charles Stanley Ball.

Boca Raton's First Hospital

Almost twenty years before the Boca Raton Community Hospital opened its doors, another hospital served area residents. It was called Stanley Memorial Hospital.

Located in a government-built administrative building of Palmetto Plaza on Palmetto Park Road and Southwest Second Avenue, it became Boca Raton's first hospital sometime in 1948. It was owned and operated by Dr. Charles Stanley Ball, an osteopath.

Carl Douglas, who was born with the aid of a midwife in Boca Raton on April 6, 1919, stated the hospital was "small with only a few beds." He said it was staffed with nurses and its biggest contribution was the delivery of over "a hundred babies."

Carolyn Douglas, Carl's wife, delivered their son Chip in the hospital in 1949. Pat Jakubek, who has lived in Boca Ration since the early 1940s, remembered visiting Mrs. Douglas at the hospital in late October 1949 with her mother to congratulate the new parents.

Dr. Ball performed many operations, according to Douglas, who recalled, "He operated on John James, a colored man from Pearl City. He had cancer."

The hospital closed around 1950 when Dr. Ball suffered a stroke. Later, the building was used as an overflow facility for the Boca Raton Elementary School, located right down the street. The city remained without a hospital until the late 1960s.

Boca Raton Community Hospital

Sparked by the tragic poisoning deaths of nine-year-old Debbie and three-year-old Randy Drummond in 1962, the Debbie-Rand Foundation, Inc., was formed. Believing the children could have been saved had there been closer medical facilities, a campaign was launched to build a hospital in Boca Raton.

Eighteen civic-minded women, who recognized the need for a hospital, formed the Debbie-Rand Memorial Service League, Inc. (DRMSL), an offshoot of the foundation. Their mission was to "raise funds [and to] coordinate volunteer services and other beneficial activities for the establishment of a hospital in Boca Raton as proposed by the Boca Raton Community Hospital, Inc., formerly the Debbie-Rand Foundation, Inc." Mrs. Gloria Drummond became the league's first president.

During the five years it took to raise the necessary funds, hundreds of volunteers joined the DRMSL. The enthusiastic league took over the old Boca Raton Community Church building on East Royal Palm Road, gave it a face-lift in shades of pink and dedicated it as the league's first thrift shop.

Along with the thrift shop, the organization held several fiestas, which included golf and bowling tournaments, a children's fair, street and boat parades and street dances. They also added annual balls, luncheons, fashion shows and smaller moneymakers. By July 1966, the DRMSL donated more than $240,000 to the hospital project.

In 1967 Boca Raton Community Hospital (BRCH) opened on Meadows Road as a 104-bed nonprofit facility. Since then, the hospital—known as the "Miracle on Meadows Road"—has experienced many milestones. And it is slated to experience yet another.

Helen Miller volunteered in the Boca Raton Community Hospital as a member of the Debbie-Rand Memorial Service League. *Photo courtesy of Debbie-Rand Memorial Service League.*

Partnering with the University of Miami and Florida Atlantic University, plans are underway to build a new community hospital on thirty-eight acres of the Florida Atlantic University campus. The hospital will serve as a community medical facility as well as the primary teaching hospital for FAU's physician education partnership with the University of Miami Miller School of Medicine. The facility is projected to open in 2011.

The Debbie-Rand Memorial Service League continues its commitment of support and service to the hospital with several of its original members still volunteering their time to serve patients and raise money for its causes.

Joan Wargo, who currently serves as a corporate board member of the BRCH, is a charter member and past president of the DRMSL. Her forty-four years and over 27,000 hours of volunteer service embody the spirit of the hospital.

West Boca Raton Medical Center

A part of Tenet South Florida Health System, the West Boca Raton Medical Center became Boca Raton's second hospital when it opened on February 2, 1986. Built to serve west Boca Raton residents, it offered a full range of services including twenty-four-hour emergency care, outpatient surgery and physical therapy.

Over the years the hospital expanded its capacity to serve residents by adding a maternity unit. Expected to deliver one thousand to twelve hundred babies during its first year, it delivered its thousandth baby just seven months after opening.

Today the hospital serves an expanding west Boca Raton population.

BURYING THE DEAD

The Black Community

In the black community, early residents who passed away were embalmed in West Palm Beach then returned to the community. Memorial services usually took place on Sunday mornings when most of the community was off from work. Residents would prepare food and take up a collection for the bereaved family. Lois Martin commented:

> The procession went in to Delray for burial. That cemetery was at Eighth Avenue and Germantown Road in Delray. You see, that's the only cemetery in Delray. Now, what happened was that they had the blacks being buried in one end and the whites on the other end in that cemetery. So even in death we were still segregated.

While Woodward Insurance sold $250 insurance policies to black residents, burials ran as high as $300 to $400. If the insurance didn't cover the costs, the insured made weekly or monthly payments. Many times property was exchanged instead of money.

Some blacks who worked on Butts Farm said when farm hands died who couldn't afford to be buried, Butts had an insurance policy that provided for their burial on the farm.

The White Community

In 1916 Frank Chesebro donated a one-acre site on his property to be used as a cemetery for whites. That site was located on what is now the Royal Palm Yacht & Country Club. The town did not own the cemetery; instead, an association of plot owners was formed with each member paying five dollars per burial. Chesebro was elected association president.

The trustees of the Boca Raton Cemetery adopted the following rules and regulations:

A memorial monument was placed in the Boca Raton Cemetery and Mausoleum to honor all veterans. *Photo courtesy of the Boca Raton Historical Society.*

We intend to make a beautiful little park of the place and to care for it as long as we have friends there. The land has been deeded to us and can never be used for any other purpose. Everyone can have their choice of location for a grave or family group providing it does not interfere with our general plan. Relatives can erect headstones and plant flowers as they choose. An accurate record of all graves will be kept. The superintendent and Trustees get no pay for their services—only for actual labor performed.

A total of twenty-five burials took place at the cemetery between 1916 and 1927. The Cochran baby was the first. While the gender of the child was not documented, we do know it was 1½ years old and died November 14, 1916. Of the twenty-five burials, thirteen were children under twelve years of age.

The cemetery remained at that location until Geist bought the Ritz-Carlton Cloister Inn from Mizner along with additional lands occupied by the cemetery. He traded ten acres near the waterworks for the one-acre plot, negating the association's original intention that "the land has been deeded to us and can never be used for any other purpose."

On May 22, 1928, the bodies were exhumed and moved by horse and wagon to the new site at the northeast corner of Second Avenue and Sixteenth Street, just north of what is today Glades Road.

Between 1928 and 1942, forty-two persons were buried at the cemetery. Fifteen were children under age twelve. They remained at peace until the heavily guarded, top-secret Boca Raton Army Air Field moved onto land that encompassed the cemetery. Due to the heavy security imposed by the military, funeral homes and those visiting loved ones found it difficult to visit the gravesites. To solve this problem, Lieutenant Colonel Arnold MacSpadden of the U.S. Army Corps of Engineers selected Sunset Hill—a ten-acre site in town—for the new cemetery. From the fall of 1942 to the spring of 1943, the remains of sixty-seven persons were transferred to that location.

In 1948, the cemetery was turned over to the city and the fire chief became the first cemetery sexton. He sold, marked and measured the graves. Today the cemetery is called the Boca Raton Cemetery and Mausoleum. It is located at 451 Southwest Fourth Avenue.

Spearheaded by Harry Chesebro, a memorial monument was placed in the cemetery to honor those who served in our armed forces. Attending the 1962 monument dedication were Lieutenant Colonel Arnold MacSpadden, the engineer who built the Boca Raton Army Air Field; Dr. William G. O'Donnell, Boca's first physician; and Mrs. Harry Chesebro, whose family donated the land for the first cemetery. The marker was dedicated to the Chesebro family and Dr. Laurence Gould, one of Boca Raton's first teachers and a world-famous explorer, who composed the second paragraph on the war memorial. It reads:

> *A memorial dedicated to the memory of those buried here who served in the military forces of our country in all its wars. At the rising of the sun and at eventide we will remember them and dedicate ourselves to the cause of peace for which they served and sacrificed.*

WAR IN PARADISE

World War II dramatically impacted the decade of the 1940s and brought massive change to the small community of Boca Raton. Almost overnight, the town's 1942 population of 723 exploded to reach a high of over 20,000 in 1944, as the Army Air Corps established the country's only top-secret airborne radar training facility just west of town. The Boca Raton Army Air Field (BRAAF) impacted every facet of life for Boca Raton residents and became the catalyst for the city's future growth.

Excerpts in this chapter are taken from my book *Small Towns, Big Secrets: Inside the Boca Raton Army Air Field during World War II*. To read a detailed account of the base and the impact it had on Boca Raton, please pick up a copy.

GERMANY ON THE HUNT

By 1939 German armies were well entrenched in Europe and Hitler set his sights on the key remaining European obstacle—Great Britain. If the island nation fell, the Third Reich had a straight shot at their ultimate target, the United States. With Japan pushing west from the Pacific and Germany pushing east from the Atlantic, the two countries hoped to catch America in a squeeze play and render her comatose.

But England was not about to roll over and play dead. Instead, she declared war on Germany. In response, in June 1940 Germany dropped its first bombs on London. With electricity sputtering, research and development came to a halt on a new secret device—the resonant cavity magnetron—a second-generation airborne radar device that would put the Allies ahead in the air war.

Tizard Mission Heads to Washington

To convince top U.S. officials to assist in the continuing development of this vital war-worthy device, a clandestine group of British scientists, politicians and military experts,

called the Tizard Mission, traveled to Washington. After much discussion with high-level politicians, an agreement was reached and the Rad Lab, a classified research and development laboratory, was established on the campus of the Massachusetts Institute of Technology (MIT).

With windows painted black and guards monitoring the building twenty-four hours, seven days a week, on the ground floor of Building #4, sixteen scientists from the United States and the United Kingdom secretly set to work.

Boca Tapped for Base

In 1940 a whisper came down from Washington that top military brass were on the hunt for Florida land on which to build several large bases. These bases would be established in preparation for the prospect of entering the war against Hitler's rolling armies.

At the time, Boca Raton, known mostly by upper-crust Midwesterners for its exclusive and luxurious Boca Raton Resort & Club, wasn't even a blip on the government's radar screen. However, Boca Raton's mayor, J.C. Mitchell, a savvy politician, got wind of this whisper and with the blessing of the town council, traveled to Washington to lobby for his humble community to become one of those sites.

On December 7, 1941, the Japanese bombed Pearl Harbor, plunging the United States headlong into World War II. In reaction to this, plans for the bases moved at an accelerated pace. Because Boca Raton already had a small airport, was located near the ocean (for bombing runs) and had excellent weather, it was eventually tapped as one of those sites.

The sleepy town was soon to be jarred awake by the giant military complex.

Hitler's U-boats

The beginning of 1942 brought destruction along the eastern shores of the United States as Germany launched Operation Drumbeat. A well-planned U-boat assault, it targeted freighters and tankers traveling the East Coast shipping lanes that brought lifesaving supplies—oil, food, medicine and materials—to England.

To prevent ships from being silhouetted against shore lights, blackout curtains were ordered hung in homes and businesses along the beaches. In addition, spotting towers sprang up every three miles up and down the East Coast of the United States, including Boca Raton. Residents and military wives manned the towers to watch for German U-boats and planes. Among those in Boca Raton who answered the call were Jessie Barrett and her children, Martha and Peter. Together, they spent three hours every Friday afternoon looking out to sea. Peter Barrett recalled:

> *The watchtower was located several miles north of Palmetto Park Road, stood about thirty feet high and was painted a dreary navy gray color. The platform held an enclosed office area with windows and there was a walkway around the platform. Inside the office were two phones, one of which was red in color. We were told in no uncertain*

Civilians watching for German planes and submarines manned the spotting tower erected on the beach several miles north of the pavilion. *Photo courtesy of the Boca Raton Historical Society.*

terms that we should never touch the red phone unless we saw something very important. Study materials, showing the silhouettes of submarines and aircraft, were scattered about the table. Photos and diagrams were stuck to the wall and black, hard rubber models of aircraft hung from the ceiling.

On May 8 at 12:13 p.m. several miles off Boca Raton, the *Ohioan*, carrying 6,000 tons of ore, 1,300 tons of licorice root and 300 tons of wool, came under attack by *U-564*. It sank in two minutes in 550 feet of water. Of the thirty-seven crewmen, fifteen lost their lives.

In the first six months of Operation Drumbeat, the Germans sank 397 ships and killed close to five thousand crewmembers. Between February and May, 24 ships went down off the Florida coast, 16 within a 150-mile stretch from Cape Canaveral to Boca Raton.

Edward Barrett, Peter's paternal grandfather, gave this account of what happened when visiting friends witnessed a sinking: "The shock of seeing the ship torpedoed before my friends' eyes was so great as to halt their northern trip for two hours at Delray Beach, and to put one of the ladies in the hospital in New York for a week after they reached home."

In late 1942, the U-boats were driven south into the Caribbean by U.S. aircraft flying bombing runs. But before that happened, a little-known incident took place on the beach in Boca Raton.

German Spies Come Ashore

One night, a loud banging on their front door awakened Jessie, Martha and Peter Barrett. When Jessie opened the door, she came face to face with two military police (MPs) stationed at the Raton Club.

The MPs told her that there was a report of blinking lights coming from their direction. Insisting their blackout curtains were in place and the household asleep, Jessie suggested they look at Dr. Sanborn's empty home next door.

According to Peter Barrett, when the MPs arrived at the Sanborn home, they noticed the back door was ajar. Inside, they found empty food cans in the kitchen, damp towels in the bathroom and rumpled sheets in the bedroom. In the front of the house pointing out to sea was a telescope and signaling device.

Charles Sanborn Hutchins, great-nephew of Dr. William Sanborn, told the rest of the story: "When the MPs left the house to inform the FBI, they closed the back door which inadvertently locked. Not wanting to reenter the house without permission, the FBI phoned my great-uncle to get permission."

Just south of the Palmetto Park Pavilion on A1A, a portion of the wall that once surrounded Dr. Sanborn's home still borders a public beach access path between the Beresford and Excelsior condominiums. On November 12, 2005, Mayor Steven Abrams commemorated the historic site where spies landed on Boca Raton soil by unveiling a plaque on the wall. It reads:

On this spot in June 1942, spies from a German U-boat landed and occupied the home of Dr. William Sanborn built on this site in 1937. The subs, deployed during World War II as part of Hitler's "Operation Drumbeat," torpedoed tankers and freighters traveling the East Coast shipping lane carrying vital supplies to the U.S. and England. The Germans sank 397 ships and killed 5,000 people. Twenty-four ships sank off the coast of Florida, 16 between Cape Canaveral and Boca Raton.

Martha Barrett Bell; her brother, Dr. Peter Barrett; and Charles Sanborn Hutchins attended the ceremony.

Land Acquisition

On May 16, 1942, the secretary of war of the United States signed a decree that allowed the government to take ownership of 5,860 acres west of Boca Raton. The land was bound by Dixie Highway on the east; the Seaboard Railroad on the west; Palmetto Park Road on the south; and Fifty-first Street (Yamato Road) on the north.

Henry Van Rolle, a squatter, remembered that time: "Out of the clear blue sky this man came there and said, 'Hello, you've got to move,' because our houses were close to the army camp. Well you know what they did? They paid for every house to be hauled away and we all just moved."

The Hideo Kobayashi family, Japanese farmers from the Yamato Colony who stayed on after the colony disbanded, also owned land acquired by the government. Tom Kobayashi was fourteen at the time. He remembered that day:

The FBI came by in the morning with a warrant to search the house for anything they wanted. They took a shotgun, radio, books on Japan, and a small toy signal set, a present when I was younger that I had thrown into the attic. They told me, "Did you know you could send messages to the German subs a couple miles away with this?" They confiscated it.

With the last of the families relocated, the Boca Raton Army Air Field (BRAAF) was poised to emerge from the sands west of Boca Raton.

Boca Raton Resort & Club Houses Troops

While the Boca Raton Army Air Field was taking shape, the luxurious Boca Raton Resort & Club was commissioned to serve the military. It became home to the Army Air Corps Technical School of Radar and housed cadets on their way to Yale to become commissioned officers. Among those cadets were a number of African Americans who later became known as the Tuskegee Airmen. Lieutenant Jacob Beser, radar countermeasure officer aboard the *Enola Gay*, also trained there.

The facility was stripped of its expensive rugs, paintings and furniture in preparation for the thousands of troops that would occupy its guest suites. In addition, tents were erected on its lawn and foxholes dug into its golf course.

Louis Mikunda arrived at the club in the summer of 1943. He wrote,

> There were over 2000 Air Force Cadets in residence at a time and the conditions were anything but "elegant." The rooms had been stripped of carpets and furnishings and contained eight bunks to a room (Green G.I. bunk beds, 4 uppers, 4 lowers). When PT [physical training] ended at 3:30 p.m. and we were to clean up from the obstacle courses and sand football games to dress up for Retreat at 4:00 p.m., there was no water pressure above the second floor—all faucets turned on simultaneously. So we filled the tubs before PT and after PT took turns bathing in the same water. Turns were decided by lottery, and #8 also had to clean the bathroom for possible white-glove inspection during Retreat or dinner. The swimming pool was boarded over. All the grounds and part of the golf course had tents pitched on them where incoming trainees spent their first 2–3 weeks.

It wasn't until the end of 1944 that the hotel returned to civilian control.

BUILDING THE BASE

Because of high demand for a facility where troops could be trained in the installation, operation and maintenance of airborne radar, Command Headquarters fast tracked the building of the base. In four short months, four runways and eight hundred buildings emerged from what was once white sand and palmettos. The base opened on October 15, 1942.

Veteran Ed Wallish gave a physical description of the base:

> The main base was divided into three areas: the north, central and south. The airfield was located to the west of the central and north areas, the base hospital was located on the southwest part of the base and the town of Boca Raton and the Atlantic Ocean was to the east.
>
> Most of the other buildings on the base were of wood frame, tarpaper covered construction. There were movie theaters, mess halls, airplane hangars, gymnasiums, post exchanges (similar to a department store), fire stations, office buildings and the hospital. There were some warehouses of concrete construction and "L-shaped" cinder block barracks near the flight line. The "H-shaped" [radar] school buildings were also constructed of cinder blocks.

Located at the northwestern portion of the acreage, the triangular-shaped bituminous airfield was the centerpiece of the base. The remainder of the base was constructed east and south of the airfield. Trees and shrubbery, left intact, helped camouflage the facility.

6PSA-5M38-1-42-3:22:1315-12:7500-0-45°-2622N8006W-BOCA RATON AAF, FLA.(E) ← (N) #14

The top-secret Boca Raton Army Air Field (1942–47) occupied 5,860 acres west of town, contained eight hundred buildings and was built in four short months. *Photo courtesy of the Boca Raton Historical Society.*

Some accounts of the construction period note that the winding roads and haphazard placement of the buildings were due to construction deadlines—since it took too much time to remove the obstacles the engineers simply built around them. Other accounts note this was done so German subs couldn't blow out the whole system at once if the base was under attack.

Many of the original winding roads exist today as part of the city's road system. The best examples can be found from Spanish River Road south to Northwest Twentieth Street and from Northwest Fifth Avenue east to Dixie Highway.

Troops Arrive

Troops arrived in Boca Raton from every corner of the country, mostly by train. John H. Cochrane shipped out to Boca Raton from electronics school at Chanute Field, Illinois, in February 1945. Awed by his arrival in Boca Raton, he explained:

> *Imagine just having left the subzero temps of a northern winter and waking up one morning just as we ground to a screeching halt at the Boca AAF rail siding adjoining Dixie Hwy. I lifted the Pullman's window shade to see—PALM TREES! Greenery! Sunshine! This Rock Island rube, who had never been farther south than Illinois, was most impressed. And the white sand and balmy air! This was war? I resigned myself to make the best of it.*

Radar Training

The main purpose of the top-secret military post was to train troops in the installation, operation and maintenance of airborne radar. Classes were held in H-shaped buildings enclosed by a chain-link fence topped with barbed wire. An armed MP was posted outside twenty-four hours a day. Instruction lasted as little as five weeks and as many as thirteen months, depending on the equipment and training requirements.

Bob Davey, who attended radar school, explained the guarded nature of the instruction:

> *Everything was secretive. We were warned that discussion of even the word "radar" off the base was an automatic court martial. When we came into the building for class a few minutes before 12, let's say, the other class was leaving out the back door while we were allowed in the front door. When your name was called you answered with the last four digits of your serial number to be checked off and then you were checked off at the end of the six hours going out the back door the same way.*

Discrimination and Section F

During the 1940s, segregation touched every facet of American life. The military was no exception. On the BRAAF, "coloreds" assigned to Squadron F were housed in Section F, located in the northeast area of the base. Designated for black enlisted men (EMs), they had their own PX and on-base entertainment.

Archie Carswell, a Boca Raton resident, served on the base from 1942 to 1943. Of his experience as a soldier in what would become known as Section F he said:

> *I had to take the truck I usually drove soldiers in and use a winch to pull down a water tower that used to be on the Japanese man's land [Kobayashi]. It was a beautifully carved thing and I hated to do it. They kept the Japanese separated like they kept the*

Soldiers were trained in the installation, operation and maintenance of airborne radar, a highly secretive and recently developed technology. Its ability to receive signals at night and through overcast skies helped the Allies win the war. *Photo courtesy of the Boca Raton Historical Society.*

black soldiers separated from the whites. They did not trust the Japanese so segregation made me feel the whites did not trust the blacks.

We were all on the base there together but we could not eat at the same place and we could not have recreation or training together. It made us wonder how you were going to fight a war and expect a man to put his life on the line for America. I felt that we were both fighting the war so we should fight together.

Boca Raton Experiences a Gold Rush

Boca Raton was ill prepared for the influx of so many troops. This caused housing to become a precious commodity eagerly sought after by troops and military wives. Local residents did what they could, renting out rooms or homes. Lillian Race Williams, who lived with her widowed mother in a small two-bedroom house at 301 Southwest First Avenue known as Singing Pines, took in boarders. She noted in her memoirs that at one point there were seventeen sleeping in the house.

Sleeping quarters weren't the only commodity in demand. Decent cuisine was also sought by troops tired of mess hall food. In her article "World War II in Boca Raton: The Home Front" in the *Spanish River Papers*, Drollene Brown wrote:

> *Max Hutkin likened it to the "gold rush of the Klondike." Hungry Army personnel soon discovered the Hutkins' store. Max and his wife, Nettie, got up each morning at 3 a.m. to make thousands of sandwiches, which would be sold each day by 2:00, for 15 cents each.*

Other residents and area businesses also reaped benefits by supplying vital goods and services to the base that included food, laundry and printing services, gasoline, transportation and manpower.

The Role of Civilians and Working Women

Civilians were vital to the overall operation of the base and served in practically every office and department, averaging 1,200 at any given time and peaking at 1,500. Some of the workers came from Boca Raton.

Irene Carswell, a Boca Raton resident, worked for two and a half years as a cashier in the snack bar in one of the white post exchanges. Irene recalled, "I was 28 when I started working there. At that time, those were the only jobs around. They were short of civilian help."

Because of the lack of sufficient civilian workers in town, personnel were drawn from Delray Beach, West Palm Beach, Deerfield Beach, Pompano Beach and Fort Lauderdale. Postal clerks Richard and Eldra Durham, a married couple, were sent up from the Fort Lauderdale Post Office.

Eldra Durham recalled an interesting anecdote when the base closed:

Civilians help the war effort by practicing first-aid techniques taught by the Red Cross. *Photo courtesy of the Boca Raton Historical Society.*

When the base closed in 1947, all postal equipment returned to Fort Lauderdale. The combination safe, borrowed from the Boca Raton Post Office, was also returned, and the Durhams moved back to their Fort Lauderdale home. In 1950 Richard Durham received a curious call from the Boca Raton Post Office asking if he could recall the combination to the base safe. They said the safe had not been opened since the base closed. Thankfully, he remembered the combination—10-15-19-42—the date the base opened.

Other local women worked and volunteered their services in the service club, the liveliest joint on post. They also planted victory gardens, bought and sold war bonds and collected metal toothpaste tubes and tin cans for recycling. Many contributed to the war effort by becoming volunteers with the Red Cross. They were trained in first aid, home nursing and emergency preparedness. The town hall hosted knitting sessions, and Mrs. Harold Butts and Mrs. T.M. Giles directed a Red Cross sewing room in the Mitchell Arcade for National Defense volunteer work. Even young girls got involved, joining the Junior Red Cross that sponsored fundraising dinners and made stuffed toys to send to British hospitals.

On- and Off-Post Entertainment

Locally, troops enjoyed USO shows held on the base or in the gym at the Boca Raton Elementary School. And many enjoyed the Boca Raton beach, accessible by Palmetto Park Road. John H. Cochrane recalled:

I still remember most distinctly walking one day to the beach through a large uncompleted subdivision on the east side. All the concrete streets were in, as were all the streetlights, but the jungle had moved back in and now covered most everything. Because I was a car buff, even back then (like most boys), I took particular note of an early 1920's Cadillac sedan back in the weeds. It was up on blocks alongside some old decrepit house. The whole scene seemed to this nineteen-year-old a living testimony to the greed and the financial folly of that earlier time.

When the troops weren't training, they were given weekend passes to go into town. With nothing much going on in Boca, soldiers carpooled or took a bus or taxi to Fort Lauderdale, Miami or West Palm Beach. Jammed with weekend military personnel, problems were bound to arise. While white troops were arrested for being drunk and disorderly, black enlisted men were beaten by civilian police, Cochrane remembered, "for not saying 'Sir' or removing their hats while talking with 'whites' or for failure to admit on the order of civilian police that they are a 'Nigger.'"

Boca Raton Field Band

Civilians and troops weathered the storm of war by enjoying the base's most beloved entertainment group, the 503rd Air Force Band. Under the direction of Captain Maurice Shorago, a service pilot authorized to fly utility aircraft, he flew around the country, recruiting members from celebrity bands. Manny Chavez, a BRAAF pilot and friend of Shorago's, recalled, "He would tell the band member that if he didn't volunteer to come to Boca Raton, he would have them drafted into the infantry."

On several occasions the group teamed up with other bands from nearby military installations to perform in parades or special athletic functions. One such occasion occurred on January 1, 1943, when a 300-piece band, formed from the Boca Raton 503rd AAF Band, the Officer Candidate School Band of Miami Beach and the famous Navy Band, entertained spectators at the Orange Bowl game between Boston College and Alabama. The bands took the form of an airplane that moved across the field.

THE BRAAF EXPERIENCES A HURRICANE

With the impending arrival of a hurricane, on October 18, 1944, the entire personnel of the BRAAF moved to the Boca Raton Resort & Club. With electricity down, no hot meals were served and all meals consisted of C rations. But because most of the soldiers had never used C rations before, a number of problems arose as described in the *History of the BRAAF 351*st *AAF Base Unit*:

> *There were a considerable number of minor to serious cuts resulting from their efforts to open the C ration cans. Disposal of the cans created a considerable problem. In addition, it was impossible to properly open C Rations without having some sort of container in which to put them. The men did not carry any mess gear, so a serious sanitation problem arose from the spilled C Rations plus the fact that there was no water for scrubbing or washing the floors.*

According to *Transmitter*, the base paper, two babies made their debut at the Boca Raton Resort & Club during the storm in the makeshift hospital. But in spite of the inconveniences, temporary overnight guests did enjoy some distraction as the 503rd AAF Band entertained them. Marion "Pint" Cornwell recalled, "There was a Big Band dance band. Some Lt. was the leader and they played great music. There was a male vocalist who came out wearing a Zoot suit and had quite an act."

NEW MISSION FOR THE BASE

After V-E Day (Victory in Europe) and V-J Day (Victory in Japan) in 1945, airborne radar training was no longer in demand. That left an uncertain future for the BRAAF.

This radar mosaic was taken by Western Electric radar through overcast skies by pilots from the Boca Raton Air Field in 1946. The image was reprinted from the *Bell Telephone* magazine, Winter 1945–46. *Photo courtesy of John E. Barnes.*

However, the airfield was soon turned into a processing and induction station for troops entering the service from south Florida.

In September, six hundred young men entered the service. While the population of the base went from two thousand in the first quarter of the year to over six thousand by the end of September 1946, that wasn't enough to satisfy commanders. By May 1947, the decision came down to deactivate the base and preparations commenced for the November 30 transfer of equipment, materials and personnel to Keesler Field in Biloxi, Mississippi.

Hurricanes Damage Base

In the autumn of 1947, two hurricanes hit close to Boca Raton. The first was a category 4 and swept ashore near Fort Lauderdale on September 17. Winds of 155 miles per hour were observed at Hillsboro Lighthouse for one minute, and five-minute sustained winds clocked in at 121 miles per hour. Damages in excess of $3 million at the BRAAF hastened its closing.

Jim Vaughtner was on the base when the hurricane hit:

> *I was in one of the L shaped buildings which were classified as a permanent type structure. Standing at a window I watched a wall of a wood warehouse rip off board by board, leaving the 2x4 studs standing.*
>
> *My cot was located in the corner of the "L" by the furnace. I had just gotten up to go to the latrine when the brick chimney came crashing down on the cot and flattened it. They say the winds were 155 but I thought they were 180!*

A second hurricane on October 12 struck Cape Sable, on Florida's southwest coast, and exited at Pompano Beach, grazing BRAAF with ninety-five-mile-per-hour winds.

Base Closes

For five years the Boca Raton Army Air Field carried out the secret mission for which it had been designed. Now, however, it was time for its gates to close. While most of the remaining service personnel shipped out to Biloxi, a small contingent of officers and enlisted men stayed behind to lock the doors. What had once been a proud training facility planted on the cutting edge of military technology had now become obsolete. Jim Vaughtner recalls the troops' last hurrah:

> *Myself plus some ten other officers and several airmen that were left at the base inventoried the base and closed up the books for the audit.*
>
> *Knowing that the balance in the Officer's Club funds had to be sent to Washington to go into the General Fund, we decided to have a big bash and dance at the hotel.*

In September of 1947, a category 4 hurricane swept through Boca Raton, causing over $3 million in damages to the Boca Raton Army Air Field. *Photo courtesy of the Boca Raton Historical Society.*

Flaming food was served and we had a waiter for each couple. Danny Kaye was at the hotel that night.

I remember leaving the hotel around 2 a.m. on a Sunday morning when a young man drove into the garage with a car that had a hood a mile long. To the attendant I heard him say, "I want the car washed and a tune-up. Have it ready by 8 a.m.!"

BOCA RATON AFTER THE WAR

The abandoned base left a multitude of structures intact that became the catalyst for growth in Boca Raton. The airport returned to civilian hands and buildings that once housed troops were put up for sale, but the military didn't pull out completely.

The Mysterious "Farmers" and Secret Biological Testing

Bob Slone, a longtime resident of Boca Raton, recalled an encounter back in the 1950s with several mysterious "farmers." But it wasn't until 2004 when Slone learned the base was used as a secret biological research center that he understood the significance of that encounter.

Through a mutual friend, Slone was able to locate "Duane" (not his real name), who was one of the farmers. He told Slone that during his forty-eight years of marriage, he never told his wife what he did in the service and he wasn't going to talk about it now. However he did verify he was stationed in Boca from 1951 to 1954 and that he was one of

eight "farmers" along with a unit of about fifty men. He also said whenever he traveled an FBI agent was with him and tried to get him to slip up and say something about the secret testing. But Duane assured Slone, "I never said anything to them or anyone else."

Eliot Kleinberg of the *Palm Beach Post* wrote in a July 7, 2002 article entitled "Veteran Recalls Secret Weapon Work at Boca Airfield" that the BRAAF was used as a secret biological weapons testing site. The following is a recap of the story from *Small Town, Big Secrets:*

> *After the base closed in 1947 a small contingent of military personnel remained behind to produce a secret biological weapon—stem rust of rye—a variation of wheat rust that "can destroy more wheat and other grass crops in less time than any other crop malady."*
>
> *Having done extensive research on the topic, Kleinberg wrote that the wheat fungus could be used on Russian wheat fields to "render wheat stalks barren and starve civilians."*
>
> *Operating from a tightly controlled installation occupying eighty-five acres just north of the BRAAF from 1952 to 1957, the wheat was grown on plots between and along runways at the old Boca Raton airfield in an area the size of one to two football fields. Fungus spores were sprayed on the wheat then in a few days the multiplied spores were harvested and stored in two-gallon vacuum-sealed stainless-steel containers.*
>
> *"The idea was to dust the spores onto chicken feathers, then load them with a bomb of sorts that would activate about 500 feet off the ground," Kleinberg wrote.*
>
> *The spores would adhere to the wheat and allow it to grow but not produce any grain. The hope was to force Soviet leaders to concede (should there be a war) or move resources to feed their starving civilians. The program was shut down in 1957.*
>
> *Kleinberg, with the help of Senator Bill Nelson, pursued this topic through the U.S. Army Corps of Engineers who, back in 1994, assembled a report on the activities at the base. In March 2003, Nelson was given a briefing and reviewed Appendix K of this report, but was unable to reveal its contents because it was considered classified information. Senator Nelson did confirm that his main concern—that no harmful materials had been left behind—was satisfied. "Duane's" specific involvement in this project still remains a mystery.*

Participants and Spectators

Entertainment

During Boca Raton's early years, one of the few places locals could go for entertainment was Boca Ratone by the Sea. By day the locals fished; by night they kicked up their heels on the dance floor. But for the most part, families made their own entertainment. Church picnics, card games with friends and sandlot baseball games were all important leisure time activities. It was the beach, however, that proved to be the most popular gathering place of all.

The Beaches

Ah-h-h-h! Soft sand, balmy surf and the warmth of the Florida sun. For decades these ingredients attracted people to Boca Raton and became the main features of the south Florida lifestyle, yet now most take these assets for granted. Not long ago these treasurers were restricted to certain ethnic groups, and portions of the sand were restricted to beachgoers altogether.

Originally, access to the sand and surf was obtained by taking a boat across the East Coast Line Canal at Palmetto Park and then walking down a narrow sandy path surrounded by tropical foliage. With the construction of the Palmetto Park Bridge in 1917, the roadway was pushed through to the beach, and the city erected the Palmetto Park Pavilion.

While white residents frolicked in the frothy surf up and down the beach until the mid-1960s, black residents were restricted to a small designated area. Local resident Henry James noted, "To get to the beach here in Boca, we had a little path north of the Pavilion. One little spot you could go there, but if you were caught in other places, they'd put you in jail...they'd put you in jail for swimming on the wrong part of the beach."

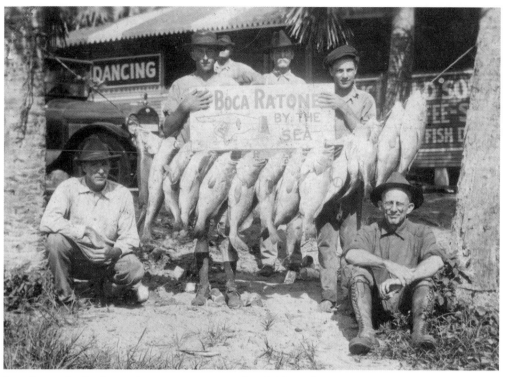

Boca Ratone by the Sea, a 1919 recreation spot, offered fishing, boating and dancing. It was located where the Boca Raton Beach Club is today. *Photo courtesy of the Boca Raton Historical Society.*

But despite the problem, blacks congregated at the beach for large family and church picnics and fish fries. Amos Jackson remembered, "Collin Spain used to carry his juke box, or piccolo, as we called it, on the beach and he had a generator…we used to have music on the beach…Later on in the day we would have baseball games."

As developers moved into Boca Raton, the beaches became even further restricted. By 1960, 4.8 miles of oceanfront property were owned by two corporations, Schine Enterprises and Arvida Corporation. Both put up signs informing the public to keep out.

Schine's holdings ran two miles south from Highland Beach, except for a small privately owned piece and the five hundred feet belonging to the city. Arvida owned 1.5 miles from Deerfield Beach northward and included both sides of the Boca Raton Inlet.

In subsequent years Boca Raton voters passed several bond issues that acquired current beachfront property north of the pavilion, south of the inlet and at Spanish River Park. This preserved the beach for generations to come.

Palmetto Park Pavilion

Constructed in 1917, the Palmetto Park Pavilion offered the public its first oceanside recreational facility and proved to be a great asset to the community. Originally a small

The Palmetto Park Pavilion built on the beach in 1917 proved popular with locals. *Photo courtesy of the Boca Raton Historical Society.*

structure, it was replaced in 1930 by a new, fancier one. Rebuilt three times since, the current pavilion was completed in 2004.

While residents and visitors spent many happy days at the pavilion picnicking, watching the full moon rise over the ocean or experiencing their first kiss, Trude W. Harr, a former park ranger who worked for the city for fourteen years, told this story about some folks who frequented the pavilion: "Occasionally there were a few regulars and once in a while a few new people. They would go to the beach to gather their psychic energies and meditate about 100 yards north of the pavilion. It was constant throughout the year, one or two at a time. They said there was a psychic triangle that included Boca Raton, Florida, Marquette, Michigan and Sedona, Arizona."

Recreation in Pearl City

Away from the beach, members of Pearl City churches held box parties to raise money for various community projects as explained by T.J. Jackson:

> *Ladies would fix boxes of food—fried chicken, you name it—and the men of course would buy it…for about fifty cents or seventy-five cents…For instance, if this lady made a box and you bought her box, she had it all decorated with crepe paper and et cetera. If you bought her box she had to sit and eat with you. People would not get jealous about that. A lot of men would like to buy Mrs. N. Parker's box because she'd always fix a big box, and had it beautifully decorated and she was a wonderful cook.*

Apron and necktie parties helped get younger people together. Older women would make a necktie and an apron out of the same material. They'd sell the neckties to the men and the women got the aprons, and according to Louise Williams, "you bought this tie and you are to wear this tie to this party. Whoever got on a apron that match your tie, that's the person you had dinner with. This was usually for the younger people, like courting girls and boys. And it was a lot of fun."

Simply sitting around and visiting, singing spirituals or just listening to folks talk was also part of the entertainment in Pearl City. When electricity came to the black community, three of the families bought radios and residents congregated at one of the homes to hear boxing matches or listen to spirituals.

But when residents itched to get out of town, Club Capaneli in Boynton Beach was the hot spot for music. It featured Louis Jones, Buddie Johnson, Sweetheart of Rhythm, Lionel Hampton and others. Other nightspots included Sunset Auditorium, Chester's and Cracker Johnson in West Palm Beach.

Delray Beach had a segregated movie theater, and the younger residents of Pearl City would hitchhike there to see movies. Later the proprietor, who lived in Fort Lauderdale, would drive through Pearl City every night on his way to work and pick up young men who wanted a ride and take them to Delray. The boys would watch the movie or meet up with their girlfriends who lived there.

During the war, adults caught buses in town and went to Fort Lauderdale for the USO shows or to patronize the black restaurants and bars.

Pearl City fielded baseball teams that would play on Sundays. Using names like Boca Raton Giants or Red Socks, they would play against other black teams in the area.

Swimming in the El Rio canal that runs along Northwest Fifth Avenue was also a pastime for younger residents of Pearl City. And despite the alligators, accounts indicated no one was lost to the beasts.

City Parks

The Anchor
By Charles Harrell

"Hoist the anchor," the captain did shout
to his crew, so rough and brave;
But the links had parted on the rusted chain—
the anchor lay in its grave.

It lay for centuries upon the sand—
beneath the rolling sea.
How do I know? You've got me there!
Though its age is plain to see.

With one hook embedded in a coral reef, it took almost one week for Boy Scout Troop 27 to salvage the 660-pound anchor. *Photo courtesy of the Boca Raton Historical Society.*

Thru toilsome efforts it was dragged ashore—
and placed upon our beach.
It proves to us that at one time
strange ships our shores did reach.

The "Old Anchor" stands as you see it today—
upon its mount of stone.
Dedicated to us by Troop 27,
the Boy Scouts of Boca Raton.

Discovered 150 feet off shore in about 20 feet of water by Saxton Crawford, the encrusted anchor was hauled ashore by Boy Scout Troop 27. Nationally known sculptor Leno Lazzari (see chapter nine) designed a pedestal and plaque for the anchor that was dedicated July 4, 1948, at the Palmetto Park Pavilion.

While the pavilion was one of the first parks in Boca Raton, Pine Breeze, sold to the town in 1915, was actually the city's first park. It consisted of a 1.5-acre site at 1100 Northwest Twentieth Street. But it was Memorial Park, the fourth city park opened in 1950, that early Boca Raton residents remember with great fondness.

Memorial Park, still there today, sat at the corner of Palmetto Park and Crawford Boulevard. Within its seventeen acres was a ball field and bleachers. It was home of the Boca Bombers, the city's amateur softball team, and it was used for a multitude of city

events. Arlene Owens remembered spending time there: "It was a good gathering place. We had Halloween contests there, and if we had a parade a lot of times it ended at the park. There was a little building there we built as a scout hut. All the citizens built it from coral rock for the Boy and Girl Scouts."

Early efforts to create community-wide recreational facilities culminated into thirty-seven city parks as of 2006. Along with a number of ball fields, swimming pools and tennis courts that help keep residents fit, Mizner Bark, the Boca Raton dog park, helps keep residents' canine friends in shape as well. It opened in 2005.

Sports

Golf

The first eighteen-hole golf course in the United States opened at the Chicago Golf Club, near Wheaton, Illinois, in 1893. Those who enjoyed the game in the North wanted to enjoy the same amenity when traveling south for the winter. In order to accommodate that request, the Ritz-Carlton Cloister Inn included two golf courses when it opened to the public in 1926.

Sporting unobstructed fairways, the courses had few undulations or noteworthy features, unlike today's rolling fairways bordered by lush tropical landscaping. With the changing of the name to the Boca Raton Resort & Club in 1930, the courses became private, open only to club members and hotel guests.

During the war when the club housed military troops, tents and foxholes dotted the golf course. Peter Barrett and his best friend, Buddy Lamont, used to visit the complex that was surrounded by a chain-link fence topped by barbed wire. Barrett recalled the two would wriggle under the fence to watch the troops:

> Every Sunday the cadets held drills on the golf course on the southwest aspect of the Club. We often attended as they marched in review and then stood at attention for very long periods of time. The Florida heat and humidity took its toll, and men often fainted. Our "sport" was to count the number that fainted each week. We were told that if anyone fainted they were "washed out" of the air corps, and that if soldiers standing next to them attempted to help, those cadets were also washed out.

After the war, the inn and golf courses returned to civilian hands and guests once again enjoyed playing golf on lush tees, fairways and greens. Later, when Arthur Vining Davis purchased the hotel property, he removed one course to make room for the first planned unit development, Royal Palm Yacht & Country Club. Over the years, many famous professional golfers and celebrities played the course with playing professionals Sam Snead and Tommy Amour, each taking a turn as the hotel's head pro.

As Boca Raton's population increased, additional private and public golf courses were deftly carved out of sandy orange groves, vegetable farms and waste areas west of town.

Dorothy Steiner, local beauty queen who was crowed Miss Florida in 1953 and later became runner-up to Miss America, poses with Bombers pitcher Arno Lamb, Joan Olsson (with mitt) and Chip Douglas. *Photo courtesy of the Boca Raton Historical Society.*

Now Greater Boca Raton boasts dozens of executive and championship courses, each one ready to challenge the most ardent golfer.

Boca Bombers

One of Boca Raton's early claims to fame came wrapped as an amateur softball team known as the Boca Bombers. Started by the Lions Club of Boca Raton in 1948, the team was originally made up of local players. One of them was Carl Douglas, a Boca Raton native. He played second base, occasionally shortstop and doubled as the manager.

Part of a very competitive league, the May 4, 1951 issue of the *Pelican*, Boca Raton's early newspaper, noted among the lineup a new pitcher by the name of Arno Lamb, who formerly pitched for a team in an amateur softball league out in Little Rock, Arkansas. Coincidentally, he had recently become employed by the city as the new lifeguard and recreation director. "It was rumored that Lamb was earning $1,500 a month for his job with the city," said Douglas.

The Boca Raton community enthusiastically supported the Bombers by purchasing Bomber Booster stickers for seventy-five dollars each and coming out in droves to see their games. When a big game was held on the Fourth of July at Memorial Park, the Bomberettes, an all-girls' team, led the afternoon's festivities by playing a game prior to the Bombers' main event.

The team won the state championship in 1951. For a time the trophy was kept at the chamber of commerce on Federal Highway, when it was located across from the city hall. In early 2006, Pat Jakubek led a search for the trophy at the chamber of commerce and Old City Hall. She lamented, "It is not to be found."

During 1951 many of the players left to play on other teams and the Boca Bombers' short-lived fame ended. But for a few years, they were the pride of the city.

Tennis

Clarence Geist, owner of the Boca Raton Resort & Club, is credited with bringing tennis to Boca Raton in the 1930s. However, it wasn't until 1967 under the Arvida ownership that the private club's six clay courts held a professional tournament for the U.S. Professional Lawn Tennis Association.

Several years later, the Boca Raton Resort & Club hosted the Virginia Slims Tennis Tournament. It featured a seventeen-year-old Fort Lauderdale player by the name of Chris Evert. She defeated Kerry Melville to win the title, one that launched her five-and-a-half-year, 125-match winning streak on clay.

Arvida brought the Pepsi Grand Slam to Boca Raton in 1977. Held at Boca West, a 1,400-acre Arvida-built residential and resort development west of town, the tournament offered a winning purse of $250,000, one of the largest in tennis at the time.

The match featured the men's top four tennis players: Bjorn Borg, Jimmy Conners, Andriano Panatta and Manuel Orantes. Other tennis greats attended the tournament, including Ille Nastase and Stan Smith, who gave clinics.

Over 14,000 fans turned out for the weekend event that included local youth serving as ball persons and workers for Pepsi, the tournament's sponsor. In the end, Borg proved the victor with Conners as the runner-up.

The tournament continued for four years with other tennis greats such as Guillermo Vilas, Vitas Gerulaitis and John McEnroe competing for the large purse. Borg won each of the tournaments, facing Conners in three of the four finals.

Royal Palm Polo

Polo has a long and rich history in Boca Raton. Arthur Vining Davis, owner of the exclusive Boca Raton Resort & Club, introduced polo to Boca Raton in 1955 by constructing several fields south of the hotel, property that is now Royal Palm Yacht & Country Club. In 1958 Royal Palm Polo relocated to property on Glades Road and one year later moved to another ninety-acre site on the same road, currently the location of Houston's Restaurant, Macaroni Grill and the Marriott Courtyard.

John T. Oxley, a polo player from Tulsa, Oklahoma, assumed management of the club in 1968, turning south Florida into "the Winter Polo Capital of the World." Under his leadership, the club grew in size and prestige. Two years later as playing captain, the team traveled to England and defeated Prince Philip's Windsor team, the first American team to take England's Gold Cup.

Acquiring 781 acres in 1970 between Jog Road and Military Trail, the Oxley family built a multimillion-dollar state-of-the-art sports complex that included seven polo fields, 320 stalls, a stadium and other amenities. Families parked their cars next to the fields and picnicked during the matches. Between periods known as "chuckers," fans helped repair the field by stomping divots made by the ponies back into place. (Of course, they had to be careful not to stomp other things in the process.) Later the family sold 641 acres that eventually became the Polo Club of Boca Raton, an upscale residential community.

In the 1990s, both John T. Oxley and his son, John C. Oxley, were inducted into the Polo Hall of Fame. The club won the 2001 U.S. Gold Cup and hosted two U.S. Open championships in the new millennium. The facility continues to be an outstanding venue in which to play and watch polo.

Sports Car Races

Miami may have its NASCAR NEXTEL at the Miami Homestead Speedway and Hialeah its former stock car races at the Hialeah Speedway, but in the late 1950s Boca Raton had its sports car races.

Ten years after the Boca Raton Army Air Field closed, its former runways became a racetrack on which the first Boca Raton Sports Car Races took place on March 10, 1957. Sponsored by the Boca Raton American Legion Post 277, it was sanctioned by the Florida Region of the Sports Car Club of America.

A small race its first year, in the second year over one hundred drivers entered. The course was 3.5 miles in length and considered one of the fastest and safest courses in

INFORMAL MOMENTS COURTSIDE

Mary Lou Metzger could not help but catch Andiano Panatta on the court.

Our own tennis pro, Jim O'Brien chats with Jimmy Conners before the tournament began.

Manuel Orantes on the courts meeting Jimmy on Friday.

Bjorn Borg, winner, & Jimmy Conners, runner up, got ready for the Big One by practicing together a few days before their match.

Ille Nastase could be found where the gals were before the finals match, & didn't mind letting them pose with him for a few pictures.

Stan Smith clinics ever of Pepsi.

EVEN THE KIDS GOT INVOLVED!

Liz Zurawski and Cory Smith worked for Pepsi Cola Saturday and Sunday passing out visors and free tee-shirts.

Laura Doyle, Yvonne Walbridge, Adrienne Walbridge and Kim Tepe were put on Pepsi's payroll for the tournament. They also passed out visors to fans.

Tryouts for ball persons: back row-Jeff Bingo, Jimmy Walbridge, Shields Farber, Jimmy Lundsford, Bob Kenney, Mike Longley, and John Hall. Front row-Keith Anderson, Warren Woodcock, Chris Longley, Chris McMechan and Dave McMechan.

A composite of photos from the 1977 Pepsi Grand Slam printed in the March 1977 issue of the *Boca West Newsletter. Photo courtesy of Haydee Walbridge.*

tennis
clients

THE PEPSI GRAND SLAM —
Boca Westers Were Involved

1st ANNUAL BOCA RATON SPORTS CAR RACES

MARCH 10, 1957

sponsored by

BOCA RATON AMERICAN LEGION POST 277

sanctioned by

Florida Region of the Sports Car Club of America

〰〰〰〰 SOUVENIR PROGRAM 50c

The former army airfield was the site of Boca Raton's first sports car races in 1957. *Photo courtesy of the Boca Raton Historical Society.*

the South. During the warm-up, American and European sports cars clocked speeds in excess of 170 miles per hour on the straightaway, a feature of the course. The longest race was thirty laps around the track.

Entries included such racing machines as Lotus, Porsche, Jaguar, Morgan, Alfa Romeo, Maserati, Fiat, Zagato and Turner. William Bowman, John Cockrane, Jean Speidel, Johnny Cuevas, Roy Schechter, Ed Wilson, E.J. Bennett and Harry Fry represented Miami. Fort Lauderdale's entries included drivers James Fritz and Frank Babcock.

The sports cars are now silent and the Bombers no longer hit fly balls out of the park, but the city moves into the new millennium well equipped. With a compliment of well-run parks, commercial sporting venues and beautiful sandy beaches, residents and visitors alike are enticed to partake of all Boca Raton has to offer.

ART AND CULTURE

MIZNER'S DREAM

When one thinks about Boca Raton, the Boca Raton Resort & Club quickly comes to mind. Formerly the hundred-room Mizner-designed Ritz-Carlton Cloister Inn, it was later enlarged and redecorated by Clarence Geist, the Arvida Corporation and several subsequent owners. This building stands as a timeless example of art and culture and is the crown jewel of Boca Raton.

The incomparable structure was originally furnished with Mizner's private collection of rare antiques from old churches and universities in Spain and Central America. Along with its Spanish-influenced architecture, tiled fountains, wrought-iron grillwork, exposed loggias and high arched ceilings, the famous resort continues to attract guests wishing to revere its history and pamper themselves in luxury.

What Mizner envisioned in the mid-1920s continues to influence the architecture of today's Boca Raton. Tours of the Boca Raton Resort & Club, focusing on the original Cloister Inn, are available during season facilitated by the Boca Raton Historical Society.

BOOKS AND BEGINNINGS

At first glance, the history of the Boca Raton Library may seem as boring as eating saltine crackers. But in reality it is more like eating key lime pie—it has tang.

Its history goes back to the 1920s when a flourishing Women's Club took on the task of developing a small community library. Mrs. Morris Stokes spearheaded those efforts and interested her friends from Chicago in the project. Soon a stockpile of books emerged, donated by local residents to the library located upstairs in the Engineer's Office of town hall (currently the administrative offices of the Boca Raton Historical Society). Mrs. Charles Stokes, Mrs. W.C. Young, Ms. Crosby Tappan and Mrs. Erma Habercorn served as volunteer librarians. Additional books were acquired when the women held musicals using local talent, with the price of admission

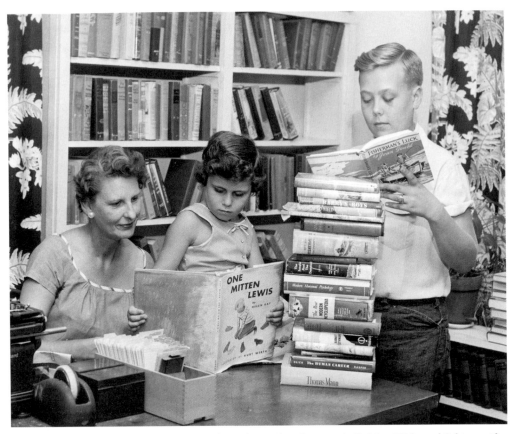

Children enjoy books at the Boca Raton Library located in the town hall. Mrs. Hildegard Schine, wife of J. Meyer Schine (owner of the Boca Raton Resort & Club), built shelves and put up curtains. *Photo courtesy of the Boca Raton Historical Society.*

being a donated book. But with the land bust of the 1920s, support for the library disappeared.

In the late 1940s the Women's Christian and Civic Club revived the desire for a library. The organization's membership included wives of Boca Raton Army Air Field personnel and local civic-minded women. Mrs. Roberta MacSpadden, whose husband built the Boca Raton Army Air Field in 1942, served as its president.

For a time, the Administration Building at the Garden Apartments on Palmetto Park Road housed the library. When a September 1947 category 4 hurricane swept the roof off the building, the library closed and the Women's Christian and Civic Club dissolved. But the dream of having a library never died.

In April 1948, the library once again took up residency in the town hall and a library board was elected. Its members were President Eleanor Bebout, Carrie Sperry, Dorothy Cox, Helen Mann and Myrtle Fleming.

Hildegarde Schine, whose husband bought the Boca Raton Resort & Club, helped revitalize the cause. She hired carpenters from the club to build shelves in the Old City

Hall to accommodate books moved from the Administration Building. She also spruced up the room by adding florescent lights and draperies. But soon the women wanted a real library.

Schine and MacSpadden, appointed to spearhead these efforts, decided to start an Art Guild to benefit the library fund. Their first fundraiser was an open house, accompanied by an arts and crafts show. Relying on her contacts with several gallery owners in Miami and West Palm Beach, Schine brought in art by Renoir and Manet. Held in the Old Town Hall, the open house was attended by over one thousand people.

The Art Guild also went on to sponsor many more events. But all was not harmonious. Schine recalled the division the groups faced in a 1976 edition of the *Spanish River Papers*:

> *Before long we had accumulated over $85,000. These women were wonderful and worked so hard on the musicals, card parties and teas. But you know how women are. They argued one against the other and the library people decided to split from the art people.*
>
> *My husband had previously given me a lot for the building that would incorporate both the Art Guild and the library. I thought the two should be together because sometimes you see a painting and want to go immediately and read about it. The library women didn't agree.*

The dispute landed in court in October 1959 with the Boca Raton Library Board filing a case against the Art Guild for an accounting of money raised by the Art Guild for the library. By January 1960, the case was settled. Schine, who had purchased a building to accommodate both groups, stated:

> *As it turned out, there wasn't adequate parking space on the building site anyway so I sold it for $50,000. I divided this equally between the library and the Art Guild. This amount plus half of the $85,000 from the benefits gave each group $67,000 to start their projects. And that was a long time ago—when a dollar was a dollar.*

Eventually, a library was built at the corner of Northwest Second Avenue and Northwest First Street with the city absorbing operational costs as part of its budget. As Boca's population increased, so did use of the library and the facility was expanded.

A new greatly expanded city library located on Spanish River Boulevard is planned to service residents living in the western part of the city. Those living in the eastern part of the city will also get a new downtown library to be built on land just north of the original city library.

Boca Raton Museum of Art

After the Art Guild and the Library Board split in 1957, Mrs. Kidd donated one lot and the Art Guild purchased five adjacent lots on West Palmetto Park Road, where the art school is today. A building soon emerged and in the fall of 1962 the new facility

An artist's rendering of the Boca Raton Museum of Art. *Photo courtesy of the Boca Raton Historical Society.*

was dedicated. But it quickly outgrew its space and the organization added three new studio classrooms.

By 1978 the nonprofit organization hired a full-time director to collect and acquire exhibitions. The outreach proved successful, and by the late 1980s another expansion became necessary. The organization also changed its name to the Boca Raton Museum of Art.

After much fundraising and city support, on January 24, 2001, the 44,000-square-foot Boca Raton Museum of Art opened debt-free at the north end of Boca Raton's Mizner Park where it shares a 5.7-acre site with an outdoor amphitheater. In 2005 the City of Boca Raton passed a resolution naming the museum "The Official Fine Arts Museum for the City of Boca Raton."

It continues to showcase a permanent collection of fine art, transient exhibits and an annual show by artists belonging to the Artists' Guild.

The Art School

The Art School took over the former museum facility on West Palmetto Park Road where it continues to be a vital extension of the Boca Raton Museum of Art. The facility currently includes eight classrooms, a faculty/student exhibition gallery, a faculty/

student lounge area, an art supply store and a variety of support facilities. Classes are taught in drawing, painting, sculpture, beading, gemstone cutting, jewelry, enameling-glass, photography and interior design.

Artists' Guild

Known today as the Artists' Guild of the Boca Raton Museum of Art, the auxiliary organization was a natural extension of the original Art Guild formed back in 1950. Within the organization, local artists found camaraderie, presented demonstrations by well-known artists, held critiques and exhibited their artwork in clubs, corporations and hotels throughout the area.

Eventually, the guild found a storefront to display juried work of members. For many years it was located in Royal Palm Plaza. Having moved several times, it is still without a permanent location, but one can see the work of many of its 450 members at over fourteen juried exhibits throughout the year.

Gallery Firsts

Realizing Boca Raton did not have a commercial art gallery, in 1971 Marjorie Margolis opened Gallery Camino Real. Herself a painter, she became very active in the Boca Raton Center of the Arts and even served as president of the Museum of the Arts for several years. For eight years, she ran an art lecture series for the city of Boca Raton, attracting major speakers from New York.

In 1988 she moved her gallery to Gallery Center on Banyan Street where she became its first tenant. Since then, Gallery Center has become home to a number of fine art galleries whose frequently changing works include sculpture, glass, paintings and ancient treasures.

Campus Culture

Florida Atlantic University's Ritter Art Gallery first opened on the FAU campus in January of 1983. The 4,537-square-foot gallery, located on the second floor between FAU's library and television-production building, opened with selections from Chase Manhattan Bank's $10-million art collection. The gallery housed rotating contemporary art exhibits as well as student and local art exhibits.

Today, University Galleries consists of two galleries (Ritter Art Gallery and Schmidt Gallery) that continue to serve the campus and extended community by exhibiting contemporary works by students, faculty and visiting artists.

Over the Airwaves

Boca Raton's first radio station began operation on January 16, 1927, as WFLA. Owned by the Chicago Equity Company, it was dubbed "The Voice of Tropical America" and

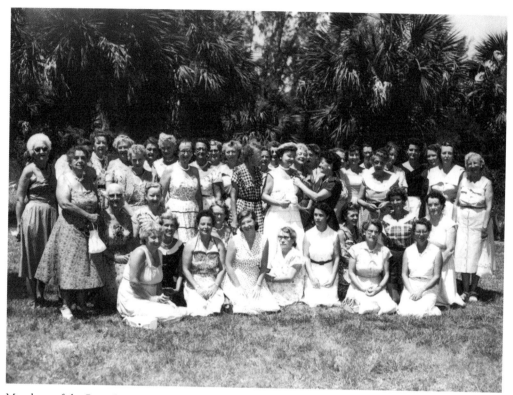

Members of the Boca Raton Garden Club pose for a group photo. *Photo courtesy of the Boca Raton Garden Club.*

was a thousand-watt station, operating on a wavelength of 440 meters. Two towers, located on Palmetto Park Road, the current site of the Art School, broadcast music and live programs throughout the area. The concrete bases on which the towers stood can still be seen on the site.

While the March 1, 1927 edition of the *Boca Raton Record* stated, "The towers looked like the hand of man had invaded some tropical setting," the studio was much less invasive. Covered with a thatch of palmetto leaves, the structure blended nicely into the surrounding foliage.

Remote feeds, made possible through telephone lines, allowed the station access to Miami and the Palm Beaches, where famous orchestras, playing at resort hotels and night clubs, could be broadcast.

What eventually became of the station is not known, although perhaps it met its demise alongside the land bust.

Shades of Color

Some of Boca Raton's oldest and most beautiful flowering trees—poinciana, Hong Kong orchid, queen's crepe myrtle and others—can be found in the wide median of U.S.

Highway 1 at Boca Raton's southernmost border. Planted by the Boca Raton Garden Club back in 1962, their presence continues to acknowledge the many women who dedicated themselves to the beautification of the city.

The Boca Raton Garden Club had its beginning on June 2, 1953, when Florence Machle invited thirty-four women to her home. By year's end, the organization boasted 119 members.

Their earliest annual project began about 1954, when the women made gifts of native material to sell at Christmastime. This evolved into Christmas House, a tour of private homes decorated by club members where handcrafted items were sold. The sale was renamed the Holiday Bazaar and remains an annual event at the Boca Raton Garden Club.

Beautification of Memorial Park (the area around the city's community center) became one of their projects. August Butts donated one hundred poinciana trees and the club planted them in the park and on Palmetto Park Road. The club was also instrumental in having the *Bauhinia blakeana* orchid tree (Hong Kong orchid) named by the city commission as "the official flowering tree of Boca Raton."

A sample of the members' love of gardens is depicted in this anecdote from the files of the Garden Club. Please note that the night blooming cereus (of the cactus family) only blooms once a year and only at night. By sunrise, the blooms are gone.

The Garden Club ladies had a tour of Casa Rosa, the home of Mrs. Lila Willingham, Garden Club member, whose home was on the northeast corner of the intracoastal on Palmetto Park Road. Her paintings hung on the walls of the Garden Club. Mrs. Willingham painted 154 watercolors, which were displayed in various parts of the country. One night after she retired, the bell rang and there was a friend with a night blooming cereus just starting to bloom. She [Mrs. Willingham] got out her paints and brushes—propped herself up in bed, and caught every phase of the flower until full bloom occurred at 3:00 a.m.

While Willingham's paintings no longer hang on the walls of the Garden Club, the location of the night blooming cereus is known. For over thirty years it has graced the wall in the Boca Raton home of Garden Club member Ruth Roosen.

In 1964 the Boca Raton Garden Club bought three lots at 4281 Northwest Third Avenue. During the summer they constructed their first building on the foundation of a boiler room that once stood on the Boca Raton Army Air Field. The building was eventually expanded and Japanese and traditional gardens planted around the building.

Beautification projects, flower shows, a children's hands-on garden and scholarships are all a part of the club's annual efforts, but one project for which they might be best known is their annual commemorative holiday ornament.

Since 1994 the club has honored the community by designing an ornament meant to commemorate a part of Boca Raton's history. Old Betsy (Boca's first fire engine), the Boca Raton Inlet Bridge, the Children's Museum, the Boca Raton Army Air Field and Yamato Colony are just some of these ornaments that are now collector's items.

HISTORICAL BEGINNINGS

Boca Raton Historical Society

The Boca Raton Historical Society (BRHS), a project of the Junior Service League (later to become known as the Junior League of Boca Raton), incorporated in 1972. In response to their mission—to collect, preserve and present information and artifacts relevant to the past and evolving history of Boca Raton, and to maintain a visible role in education and advocacy of historic preservation in our community—one of their first projects was to create a local history museum in the Old Town Hall. Leasing the structure from the city, the society relocated their offices to the second floor in 1975 and began raising funds for the building's restoration.

Since then, the BRHS has preserved or restored several historic Boca Raton structures, including Old Town Hall, Boca Raton Depot (the Count de Hoernle Pavilion), Singing Pines and the portico (porte-cochere) from the original Cabana Club at the Boca Raton Resort & Club.

The Historical Society offers a wide range of educational programs, free exhibits with topics ranging from history and architecture to arts, crafts and photography, as well as Town Hall Talks, a variety of historical topics presented to the community by guest speakers who are authorities in their fields.

Old Town Hall

During the land boom, Addison Mizner was appointed the city planner for Boca Raton. Serving in that capacity, he platted the town into an abundance of sellable lots. He also designed Boca Raton's first town hall, releasing his sketch in January 1926. The design featured a very large two-story building, following the same Spanish-style architectural details as his other designs.

Unfortunately, by early 1926 land sales began to lag, reducing real estate taxes needed to finance the large structure. Asked to scale down his design, Mizner produced a one-story version. But it proved too costly for the town. Finally, architect William Alsmeyer completed the design, using the building's original blueprint. Also incorporated into the design were Mizner's external elevations. Decorations on the first floor such as stonework and grills came from Mizner Industries.

Old Town Hall housed city government offices until 1980, when a newer structure was built on Palmetto Park Road at Second Street. The Boca Raton Historical Society and the Fire Bay Gift Shop now occupy Old Town Hall.

Boca Raton Depot

There was a Village Council that was held at the depot among the bales of hay, barrels, boxes and miscellaneous imports and exports. The depot was the place the town's business transpired. Discussions concerning road construction, surveying property, bridges, etc. [were held].

The Boca Raton Historical Society restored Old Town Hall, where they now have their offices. Their Capital Fund Drive began in November 1982, and ended in July 1984, raising $508,000. *Photo courtesy of the Boca Raton Historical Society.*

Sometimes they held dances there to the tune of banjo and fiddle. It was the main meeting place.

Diane Benedetto's description of the first "depot," really no more than a long wooden platform, depicts the vital role it played in the formation of the town. But when Geist arrived, he built a new depot (see chapter four).

Completed in 1930, the depot became an active gateway to Boca Raton. With the prevalence of automobiles, however, passenger service dropped off then ceased altogether and the depot fell into disrepair.

Hearing that the Florida East Coast Railway Station was about to be sold to a local restaurateur, the Boca Raton Historical Society successfully negotiated the purchase of the property in 1985. Four railway cars, including a caboose from the 1930s, and two streamliners (circa 1947) that once were part of the famous Silver Meteor route from New York to Miami (Seaboard Air Line), were purchased in 1987. Restored, they now serve as the Boca Express train museum. Hundreds of Boca Raton students visit the museum each year to learn about the depot and its contribution to Boca Raton history.

Singing Pines: The Children's Museum

<div align="center">

Morning
by Lillian Race Williams
July 3, 1947

I've named it "Singing Pines," when they're musical
They sing to me tunefully—
Radio playing cheerfully,
Diesel engine mooing carefully,
Poor old Hudson waiting faithfully,
All these things bringing Joy to me,
In the morning—Here beside the sea.

</div>

One of Boca Raton's oldest buildings, known as Singing Pines, is now home to the Children's Museum of Boca Raton. Built around 1912 by the Myrick family, the home originally stood on the west side of the railroad tracks, just south of Palmetto Park Road. But it was the home's subsequent owner, Lillian Race Williams, who dubbed the home "Singing Pines" and donated it to the Boca Raton Historical Society in 1976.

Just before demolition of the structure, the city dedicated land at 498 Crawford Boulevard and Singing Pines was moved to its present location. The Junior League of Women pledged to restore and maintain the structure, spending three years

Singing Pines, one of the first homes built in Boca Raton, became the Children's Museum in 1979. *Photo courtesy of the Boca Raton Historical Society.*

on its renovation. On October 21, 1979, Singing Pines officially opened as the Children's Museum.

A miniature version of the original home is on display along with 1920s period furnishings. In addition, hands-on displays entice children to explore the arts, sciences, history and the humanities.

MUSICAL NOTES

Songs of Boca Raton

Grant Clarke, noted songwriter, author and publisher, wrote the Broadway stage score for *Dixie to Broadway* and the *Plantation Review* as well as popular songs "Ragtime Cowboy Joe," "Second Hand Rose," "Am I Blue?" and "There's a Little Bit of Bad in Every Good Little Girl." He also wrote for greats like Bert Williams, Fanny Brice, Eva Tanguay, Nora Bayes and Al Jolson.

But few people know that Clarke had another claim to fame—official lyricist of Boca Raton—a title conferred on him in 1926 with the composition of a little tango entitled "In Boca Raton."

In Boca Raton

Think of an evening in June
Under a crystal-like moon
Think of an old Spanish tune
You're in Boca Raton.

Closing your eyes for a while
Dream of a tropical isle
Studded with Flowers that smile
You're in Boca Raton.

Millions of stars up above—
Shine bright
Strolling with someone you love
Each night.

Think about old Captain Kidd
Think of a chest that he hid
Dream that you've opened the lid
You're in Boca Raton.

A New York studio recorded the song but sadly, yet understandably, it never made the charts.

In 1989 the Meet Me Downtown Festival, sponsored by the chamber of commerce, introduced a new song to residents. Sung by a seven-foot-tall rat nicknamed BR for Boca Raton, the song was affectionately called "The BR Bounce." It started off with these two lines: "Wake and find a sunny day / that is life the Boca way."

Since these two songs, Boca Raton has remained without its own musical theme.

Trumpets, Violins and Tears

One of the most beloved Boca Raton musical organizations was the Boca Raton Pops, a community band formed in 1951. Founded by Philip Azzolina, the orchestra became nationally recognized. Philip died in 1970 and his son Mark took over as conductor to continue the time-honored tradition of entertaining residents in venues throughout the city. When lack of financial support forced the orchestra to disband, the city's beloved pops fell silent.

Created by the merger of the two-year-old Boca Raton Symphony and the thirty-six-year-old Fort Lauderdale Symphony, the Florida Philharmonic began its musical run in 1983. Yet once again, support for the musical ensemble failed and in 2003, the orchestra went the way of the pops. Playing to a packed house at their last concert at Spanish River Church, the audience bid the symphony a sad goodbye with a standing ovation.

ACTING INFLUENCES

Jan McArt's Royal Palm Dinner Theater

The evening of December 22, 1977, was surely one of the most glittering social events in Boca Raton, perhaps since Addison Mizner himself threw parties in 1926 at the brand-new Cloister Inn.

Women in evening gowns and men in black tie packed the 250-seat theater as cameras flashed. Jan McArt was not very well known before opening night, but she would soon become a household name in Boca Raton—and ultimately "South Florida's First Lady of Musical Theater."

One cannot tell the story of art and culture in Boca Raton without mention of Jan McArt's Royal Palm Dinner Theater. For twenty-five years the theater entertained residents and guests with rousing musical productions such as *Mame* and *Gypsy*. McArt, herself an actress, starred in at least one show each season. With the success of Boca venue, the theater expanded to Fort Lauderdale, Miami Beach and Key West.

Unfortunately, increasing debt brought an end to the for-profit theater, and in 1998 McArt reorganized it into a nonprofit organization called McArt's Royal Palm Festival Dinner Theater. But debts overwhelmed the board and the theater abruptly closed in 2001.

Caldwell Theater Company

The Caldwell Theater, co-founded by Frank Bennett and Michael Hall, opened its doors to patrons on December 5, 1975. The only professional theater in Boca Raton, its musicals, classics, revivals and original scripts entertained over seventy thousand patrons annually.

While the theater moved twice, it is now poised to occupy a permanent home on Federal Highway just north of its current location at Levitz Plaza. Renamed the Count deHoernle Theater in honor of Boca Raton's most philanthropic couple, the Count and Countess deHoernle, the intimate 325-seat theater will be home to the Caldwell Theater Company. Its greatly anticipated opening is expected in 2007.

Throughout its existence, Caldwell Theater has provided community outreach with its international storytelling, theater troupes and its seventeen-year-old Theater For Schools program, where one show per season is offered free of charge to thousands of students.

SAVING GRACES

FIRE-RESCUE SERVICES DEPARTMENT

Beginnings and Old Betsy

Everyone was there dressed in nightclothes and wrappers. The fire was raging in the wind from the sea and Old Betsy came poking along making a huge amount of noise. All the gallant men were flying in the breeze back of her hanging on for dear life. Everyone was chatting excitedly, wondering if Old Betsy and her brave men would be able to subdue the fire. Ole Betsy stopped short, backed up and ran off the road into the sand. With a roar of the engine, she was put into gear to go forward…nothing happened…try as they might she would not budge.

The flames roared higher, people stood back and panic was in the hearts of those watching. The houses were burning to the ground. Then someone realized there was no place to attach the hose for water even if they did get her out. There was one house not yet touched by the fire, the old Nelson house. Luckily the wind was from the northeast and that saved the Nelson house.

Diane Benedetto's recollection in the October 1975 edition of the *Spanish River Papers* described the grand appearance of the town's first fire truck the night several beach houses burned down.

The Boca Raton Fire Department emerged back in 1926, when the town council consented to a formal firefighting unit. They agreed to hire a fire chief at a salary of $150 per year and approved an all-volunteer fire department, not to exceed twelve members. At the same meeting, the council consented to acquire an Amer-LaFrance Fire Engine at the cost of $12,500, quite a tidy sum in those days.

The department, headed by Fire Chief Guy J. Bender, took up position in 1927. The fire engine, affectionately called Old Betsy, shared a spot in the fire hall at the town hall, currently the Fire Bay Gift Shop at the Boca Raton Historical Society.

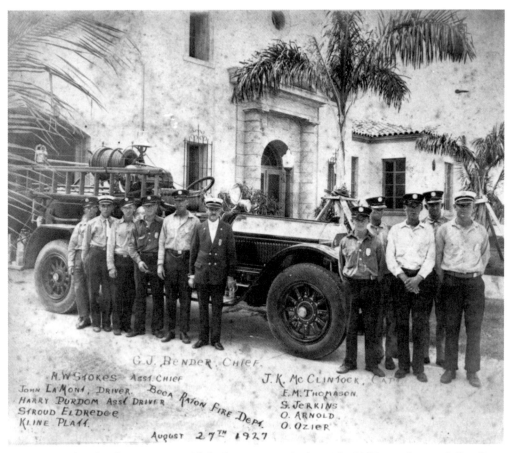

G.J. BENDER, CHIEF.
H.W STOKES ASST CHIEF
JOHN LAMONT, DRIVER.
HARRY PURDOM ASST DRIVER
STROUD ELDREDGE
KLINE PLATT.
BOCA RATON FIRE DEPT.
J.K. McCLINTOCK, CAPT.
E.M. THOMASON.
S. JERKINS
O. ARNOLD.
O. OZIER
AUGUST 27TH 1927

Boca Raton's first fire department established in 1926 stands alongside Old Betsy, the town's first fire truck. *Photo courtesy of the Boca Raton Historical Society.*

Old Betsy, manufactured in Elmira, New York, in 1925, was at the time considered state-of-the-art firefighting equipment. She was 20 feet 1 inch long, 6 feet 2.5 inches wide and 9 feet 1 inch high to the top of the bell. Along with her water pumping capabilities, Old Betsy was equipped with a chemical system, hose carrier, hard suction hose and lanterns on the rear post.

Clarence H. Horton, a field service man for American–LaFrance Folmite Corporation in Elmira, New York, delivered the first motor-operated fire truck to St. Augustine, Florida, in 1919. He also delivered Old Betsy to Boca Raton in 1927.

His daughter, Margaret Sheppard, and grandson, Allan Sheppard, a retired narcotics police officer and licensed fire inspector for the State of Florida, reminisced about the trip Horton made:

> *He was always very proud of the fact that he delivered it to Boca Raton. He drove the truck from El Mira, New York down 301 to St. Augustine then transferred to A1A. At Sebastian it was ferried across the river, on a vessel used to ferry railroad cars.*

He slept on the truck and protected himself and the truck by carrying a loaded 1911 Army model Colt 45 he retained from his service in WWI. He ate at local restaurants always keeping an eye out and never got farther than 50 feet from the truck.

In South Carolina, 301 was so bad the truck got stuck in a rut and it had to be towed out by a team of mules. He had 6 blowouts on the way down and had to contact local farmers and police officials to assist him in taking the split steel rim off the truck. Passing through Jacksonville, he stopped at the Firestation #1 to use a tool to make a modification for the steering.

When he arrived in Boca it was almost like a 4th of July parade. He was welcomed by the chief of the fire department, town council, mayor, county commissioners and even the mayor of Miami. He gave rides in the truck to all the dignitaries and later taught the chief and crew how to drive the truck and operate the equipment.

After about 10 days, he returned to Elmira by train.

Old Betsy is alive and well and resides at the old Fire Station #2 at One Southwest Twelfth Avenue. Restored to her original luster, she is seen during special events and parades and is maintained by the Explorers, a division of the Boy Scouts of America. This group, which works with the fire department, consists of fourteen- to twenty-one-year-olds interested in the field of fire and emergency services.

The old gal was seen early in 2006, when Fire Chief Bruce W. Silk retired. The department gave him a rousing send-off from Old City Hall and at the conclusion of the ceremony he slipped into the driver's seat and drove Old Betsy back to the fire station.

Today's fire-rescue department is a far cry from that of the 1930s, whose only firefighting capabilities consisted of Old Betsy, a paid fire chief and a handful of volunteers. The department currently consists of 207 certified professionals of which over 90 percent are state-certified paramedics and 10 percent are state-certified emergency medical technicians.

POLICE DEPARTMENT

When the first pioneers settled in Boca Raton there was little need for law enforcement and what was needed came from Dade County since Palm Beach and Broward Counties were not yet formed. However, with the influx of workers during the land boom that bolstered the town's population during the building of the Cloister Inn, the city felt the need to hire its own police force.

The first in a long line of lawmen to serve Boca Raton came in the form of Charles Raulerson, who became the first town marshall. Appointed on September 23, 1925, by the town commission, he served for one year at a salary of $175 per month.

Diane Benedetto told this amusing anecdote about the city's finest:

There was a problem at one time as to how to reach the one policeman the town had, so the City decided to put a red light on the dome of the City Hall. Bill Eubank was

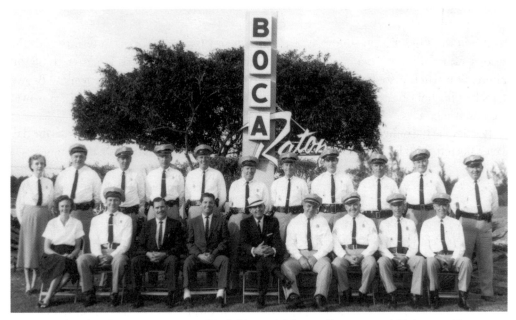

Boca Raton's police department in 1963. Hugh "Brownie" Brown (front row, middle) wears his signature trademark, a white Stetson hat. *Photo courtesy of the Boca Raton Historical Society.*

elected to do the job as he was the Town electrician…The red light on top of City Hall may have served another purpose besides calling the Chief for trouble. The Chief was very sympathetic toward the ladies of the town and often drove them up to Palm Beach for lunch and such. I am sure he livened up things for many a lonely lady. Seems that light served a convenient opportunity for this occasion. Strange reversal of the usual.

By the time the Ritz-Carlton Cloister Inn opened in February 1926, the police department numbered five, with Police Chief Ira Blackman at the helm. But after revenues plummeted due to the land bust, the city was hard pressed to maintain its force. In 1929 the town lost Blackman and requested that Palm Beach County Sheriff R.C. Baker supply a deputy during the winter season when the tourist population swelled.

Chief J.D. Padgett served the emerging town from 1930 to 1937, until Hugh "Brownie" Brown, already on the department, was promoted to chief of police. Spotlessly dressed, Brownie wore black pants and jacket, white shirt, black tie and a signature white Stetson hat. If one of his four hats ever got dirty, he shipped it to Philadelphia for reblocking and refinishing. He was said to have never carried a badge, letting his demeanor speak for itself.

Pearl City resident Lois Martin remembered Brownie: "A typical Southern policeman, he was tough and all the kids seemed to be afraid of him. He used to walk up to the car and say 'take your hat off.' That's what they say he did. But if you were black and you had a hat on, and you said something to him and didn't pull it off, he would knock it off your head."

When the Boca Raton Army Air Field moved in, Brownie lost his authority over the troops, especially the black ones. But that didn't stop him. Mary Lee Jenkins tells of this altercation when a soldier didn't take off his hat when addressed by Brownie: "Brown knocked his hat off, and then he knocked Brown's hat off! And when the fight was over we had a nice time."

But despite the difficult times, there was one occasion when Brownie really did save the day. Peter Barrett, who lived in Boca Raton from 1939 to 1946, recalled one of those times:

> One year, following a hurricane, someone found a very large alligator in the ocean near the Public Beach, apparently having been washed out of the inlet and into the ocean. The alligator was lifeless, probably as a result of rough treatment for some time in the ocean. For interest, it was hauled into a pickup truck and dumped on the lawn next to City Hall. A large crowd gathered—that is about four people—at which time the alligator pulled himself together and let it be known that he was unhappy with the crowd around him. The Boca Raton Police Force was called in to solve the problem. Our policeman, known to all of us only as "Brownie," decided that the alligator represented a threat to the populace and pulled out his trusty revolver, but attempts to fire the gun only resulted in a click. Apparently, the tropical humidity had done its worst on the gun, which had seldom been fired. Brownie bounded into City Hall, grabbed a shotgun, and finally dispatched the alligator. The citizens of Boca Raton were once again safe.

Boca Raton went through the growth spurt of the 1950s with little fanfare. Even the hiring of the department's first woman, Betty Taylor, as a dispatcher in 1957 didn't ruffle any feathers. And with the exception of the high school scuffle, the city passed quietly through the civil rights movement of the 1960s. According to *Pearl City, Florida*:

> Blacks knew their place in the white dominated City and were "yes sir, no sir" polite. Everyone stayed in his or her respective neighborhood. No riots took place and no one demonstrated with sit-ins.

After serving as police chief for 33½ years, Brownie was forced to retire in 1970 at the age of 60. At the time, forty-seven officers served on the Boca Raton Police Force. In 1977 at age 66, Hugh "Brownie" Brown died from a massive stroke.

Since Brownie's reign, many fine men have faithfully served as police chief but none has served as long or been as colorful.

Costs Then and Now

Here are a few cost comparisons to show how the city has changed since its first year:

	1926	1978	2006
Revolver	$33.89	$95.00	$800.00
Ford Touring Car	$525.00	$5,660.00	$33,600.00
One Pair Handcuffs	$11.00	$16.00	$20.00
Chief's Salary	$175.00 per month	$2,315.00 per month	$10,522.00 per month
Department Budget	$1,000.00 per year	$2.57 million per year	$28,227 million per year

Murder and Mayhem

From its beginning, Boca Raton was a quiet community, yet even in its quietness several notorious crimes left their mark.

The Unknown Grave

A handwritten history by Frank Chesebro in the mid-1930s tells of Boca Raton's first mysterious death: "About the year 1902 or 1903, the body of a young woman was found floating in the ocean east of Boca Raton. They never could find out who she was and they buried her on top of the bank a few rods south of the present pavilion. Boca Raton has its Unknown Grave."

The Ashley Gang

From 1911 to the mid-1920s the notorious Ashley Gang rode rough-shod over south Florida. They held up ships at sea, passenger trains and motorists. They openly robbed banks in the coastal communities from Lemon City (now part of Miami) to Stuart and Fort Pierce, shooting down people as the occasion required. Their exploits gained much notoriety throughout the state of Florida and beyond.

In Stuart, where the gang robbed a bank in a daring raid, John Ashley was stuck by a bullet from Kid Lowe, one of his own gang members, and lost the sight of his left eye. While seeking medical treatment, he was captured by Sheriff George Baker and a posse.

Bob Ashley, the gang leader's brother, tried to free him from jail. In the process he killed the jailer, Wilber W. Henrickson. He also "mortally wounded Police Officer Robert Riblett, of the Miami police force, in a pistol duel," according to Hix C. Stuart's book, *The Notorious Ashley Gang*, published in 1928.

Ashley lingered in jail for several months until he returned to West Palm Beach to stand trial for the Stuart robbery. Upon conviction, he was sent to Raiford, Florida's state penitentiary. Later he was sent to a road camp. It was there that he escaped with Tom Maddox, a notorious bank robber.

During this time, folks in Boca were frightened, knowing that the notorious gang was but miles from their small town. Harriette Gates wrote, "I stayed home, and mostly in the clothes closet on Board of Trade Nights. The Ashley Gang was rampant and I was a green Yankee, just down, and did not know that I should have brought with me the spirit of the Wild West.

Ashley was a fugitive for almost three years when he was apprehended delivering a load of contraband liquor in Wauchula, a town just west of Sebring. He was returned to Raiford. But once again, he escaped and was soon revisiting his old hangouts.

Hearing that the Ashley Gang was headed for Jacksonville, Sheriff Baker decided to head them off at Fort Pierce. They blocked a bridge by pulling a chain across it. When they stopped the gang, the deputies ordered their weapons tossed from the car and were intending to line them up for a frisk. But the word "handcuffs" was too much for John Ashley. He pulled a concealed weapon and a hail of bullets ensued. John Ashley, Ray Lynn, Hanford Mobley and John Clarence Middleton died in the gun battle.

Teen Angel

The spotlight shone on the quiet town of Boca Raton when murder rocked the community in 1939. Herbert Goddard, alias Charles Jefferson and a number of other names, was born in New York. He became a radio scriptwriter, producer and advertising salesman. At one time he was director of the Federal Theater in Miami.

The twenty-nine-year-old Goddard lured two young teens from their Miami homes with promises of movie careers. The girls, Frances Ruth Dunn, seventeen, and Jean Bolton, were kidnapped and driven north. Frances Dunn was killed on a secluded section of Boca Raton's north beach.

In a 1971 historical outline submitted to the Boca Raton Historical Society, Carl Douglas is quoted:

> *Mr. D. remembers the excitement stirred up in Boca in 1937 caused by a particularly gruesome kidnapping and murder: With the story that he was a Hollywood talent scout, a California man persuaded two girls into going to W. Palm Beach with him. One girl he killed on the north Boca beach, the other fled from him when he returned to town. Soon captured, Ashley (one of his names) was taken back to the scene of his crime. The dead girl had been tied to a tree, and the insects had nearly devoured her. At the sight of this, the crowd that had gathered nearly lynched the murderer right on the spot, but the police managed to control the situation. However, justice was swift for Ashley. He was tried, convicted and electrocuted.*

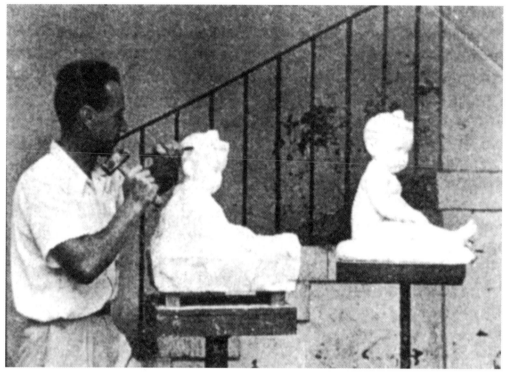

Italian sculptor Leno Lazzari puts the finishing touches to a pair of small statues in his home studio. Lazzari's statues were displayed at the Society of the Four Arts in Palm Beach during the early and mid-1940s. One statue, *Rainbow Fountain,* was purchased by the Duke of Windsor. *Photo courtesy of the Boca Raton Historical Society.*

In a July 30, 1940 newspaper article in the *Florida Times-Union* entitled "Goddard Dies in Chair for Girl's Slaying," the correspondent stated that on July 29, 1940, at Raiford, Florida's state prison, Sheriff W. H. Lawrence of Palm Beach County pulled the switch that electrocuted Goddard. Before the electrocution, Goddard was said to have apologized to the girl's parents and reassured them her "honor" had not been compromised. His last audible words were, "Goodbye Jean."

Unsolved Double Murder and Art Heist

The second sensational murders came nine years later in 1948 with the double homicide of Leno and Louise Lazzari. The internationally known Italian sculptor and his wife had just returned to their home and studio from a dinner party with friends in West Palm Beach when they were shot multiple times.

According to newspaper accounts, a number of motives were proposed. First, there was the theory that he was tracked down by Fascists because of his anti-Mussolini acts in Italy prior to immigrating to the United States in 1927. There was also the theory about the murder being tied to Leno's philandering ways, since his first wife declared her former husband was "attractive" to women. A third theory suggested the Lazzaris were

murdered because they refused to sell their lot, considered a prized piece of real estate. Another theory cites drug smuggling. Still a fifth theory alludes to robbery as the motive, even though no valuables were taken and Louise's jewelry was left behind.

The couple reportedly walked in on the perpetrator who, by evidence of a half-eaten apple, had been there quite some time before their return. The killer shot Louise once in the stomach and once in the back. Leno was shot twice in the stomach. The perpetrator stole Louise's purse, rifled Leno's pockets then fled north in the couple's jeep. Stopping in Delray Beach, the murderer tossed five .38-caliber cartridges onto the muddy shoulder of U.S. 1. The jeep was eventually found near the Florida East Coast Railway station at West Palm Beach. The murder weapon was never recovered.

The mystery didn't end with the three-year-old unsolved case. In 1951 when the Lazzaris' boarded-up studio was opened, it was found to have been vandalized. The perpetrator smashed bas-reliefs and stole twenty of Lazzari's sculptures, many so heavy it would require a truck to move them. To this day, the murders of Leno and Louise Lazzari and the heist of his artwork remain unsolved.

Hugh "Brownie" Brown was intimately involved with the case. One of his close friends, who prefers to remain anonymous, stated, "Brownie found the answer but decided to leave it alone."

The Sweetheart Murders

Thirty years later, the city experienced another double homicide when on Friday, March 17, 1978, the decomposed bodies of John Futch, seventeen, and Cynthia Rediger, sixteen, were found in a wooded area west of Boca Raton. This ended an exhaustive two-and-a-half-month search for the Boca Raton High School teens. Discovered by Michael Schindall who was riding his motorcycle in the uninhabited area near Boca Teeca, the teens were found side by side. Unrecognizable, the decomposed bodies were later identified by dental records.

The teens were reported missing on January 5 after Cynthia failed to show for an appointment to teach baton twirling and John failed to report for baseball practice. The next day, John's Pontiac Firebird was found in an irrigation canal near a migrant camp.

With hundreds of volunteers, a police dog, infrared photographs from the air, psychics and a $10,000 reward, still the pair wasn't located until Schindall found the bodies in a tunnel-like opening in a dense wall of foliage.

Sheriff's detectives spent four years tracking down Arnulfo Sanchez after getting a tip about a migrant farm worker who bragged about the killings. Finding him in Texas, Sanchez confessed to the murders and implicated an accomplice, Adam Herrera.

"The Beauty Queen Killer"

No recount of law and order in Boca Raton could be complete without mentioning serial killer Christopher Bernard Wilder. Although he didn't live in Boca Raton or murder

REWARD **REWARD**

$10,000

THIS IS THE VEHICLE THEY
WERE LAST SEEN DRIVING.

THE CAR HAS BEEN FOUND

CYNTHIA ANN REDIGER JOHN EDWARD FUTCH

FOR INFORMATION LEADING TO THE LOCATION OR THE ARREST AND CONVICTION OF THE PERSON OR PERSONS RESPONSIBLE FOR THE DISAPPEARANCE OF:

W/F CYNTHIA "CINDY" REDIGER
5 ft. 4 in. 110 lbs. Medium Build
Hair - Blonde Eyes - Hazel
Small Scar Below Right Eyebrow
16 Years Old

W/M JOHN EDWARD FUTCH
5 ft. 10 in. 155 lbs. Muscular
Hair - Blonde Eyes - Blue

16 Years Old

BOTH TEENAGERS WERE LAST SEEN IN A WOODED AREA
WEST OF BOCA RATON, FLORIDA ON THURSDAY AFTERNOON,
JANUARY 5, 1978

IF YOU HAVE SEEN EITHER OF THESE PEOPLE PLEASE
CONTACT:

**DETECTIVE LT. DONALD GOODE
BOCA RATON POLICE DEPARTMENT
AT**

368-9992

ALL INFORMATION WILL BE STRICTLY CONFIDENTIAL

A poster offers a reward for information on the whereabouts of Cindy Rediger and Andy Futch, two teens who disappeared in 1978. Their bodies were found several months later. *Photo courtesy of the Boca Raton Historical Society.*

any of his victims here (at least none that have been found), still he was intimately tied to Boca Raton. Through his electrical company, Sawtel Construction Company, that provided services to Arvida in the 1970s, he became friends with many Boca Raton residents, including this author who worked for Arvida at the time.

It was mid-March 1984 when his face flashed across every television in America. A handsome and affable man with beautiful blue eyes and an engaging personality, not one of Wilder's friends suspected he was behind the murder of a twenty-year-old model just days before.

Haydee Walbridge, property manager at Boca West, had many dealings with Wilder:

> It is beyond description what I felt when the Friday 6:00 p.m. news the week of the Grand Prix flashed a manhunt for serial killer Chris Wilder who was wanted for killing several girls in the area and other parts of the country. I was shocked, terrified and frightened to no extent, since Wilder had met my teenage daughters and I feared for their safety. The FBI then interviewed those of us who had business with Wilder and briefed us on his behavior and what to expect. The local police departments were also alerted by the FBI and provided patrol protection for a few days to the areas where we lived.

Posing as a photographer, the Australian-born immigrant lured the young woman away from the Miami Grand Prix under the pretense of making her a star. After the model's murder and realizing the law was closing in, Wilder, dubbed the "Beauty Queen Killer," went on a forty-seven-day cross-country kidnapping and killing spree. His life ended with a shot in his heart during a struggle with a New Hampshire trooper.

Those who knew Wilder learned later that he was suspected of kidnapping twelve women and murdering nine of them.

Contemporary Cold Case

In 2005 the Boca Police reopened the murder investigation of Julie Wills. A thirty-two-year-old actress, model and beauty pageant winner, she was slashed to death in her downtown Boca Raton home in 1996 during a break-in.

The May 17, 2005 edition of the *Boca Raton-Delray Beach News* quoted Chief Scott as saying, "My goal is to hunt this individual down and prosecute him before I leave. I feel confident of a successful conclusion because we've got new investigators, new eyes and new ways of seeing things."

Chief Scott left the department in February 2006. To date, the murder remains unsolved. While all evidence has been submitted for DNA testing, the results are inconclusive.

Today's Law Enforcement

The Greater Boca Raton area is served by two law enforcement agencies—Boca Raton Police Department and Palm Beach County Sheriff's Department.

With 198 officers, the City of Boca Raton Police Department serves a population of 83,860 within the incorporated City of Boca Raton.

The Palm Beach County Sheriff's Department patrols unincorporated Palm Beach County, which takes in sections west of the city. Called District 7, it encompasses forty-eight square miles and a population in excess of 120,000. A staff of five full-time detectives and a detective sergeant along with seven civilian staff assist the community.

OTHER MAJOR CRIMES

Spam Capital of the World

Boca Raton became associated with the word "spam" in the 1990s. According to MessageLabs (an e-mail security vendor), Boca Raton is the "spam capital of the world," being the source of a surprisingly high fraction of all spam generated worldwide. According to the *Miami Herald*, the city has a long history of involvement in confidence tricks. Richard C. Breeden, former U.S. Securities and Exchange Commission chairman, once called the city "the only coastal city in Florida where there are more sharks on land than in the water."

In the keynote address to a computer security conference on June 8, 2004, Bruce Sterling described the city as the "Capone-Chicago of cyber fraud." According to a number of U.S. federal indictments, as of June 2004, the Gambino family continues to operate in Boca Raton.

On July 22, 2004, Boca Raton resident Scott Levine was charged with the largest computer crime indictment [at the time] in United States history. Federal prosecutors allege that Levine unlawfully accessed databases of consumer data aggregator Acxiom to steal detailed personal information about millions of persons.

In a followup 2006 e-mail, Bruce Sterling, author of techno-thrillers, wrote: "I hope things there have shaped up since 2004, but I've got reason to doubt it."

Anthrax and AMI

Of course, the most notorious of Boca Raton's unsolved mysteries surrounds the 2001 anthrax attacks. Three weeks after the 9/11 terrorist attacks on the Twin Towers in New York, anthrax was introduced into the America Media Building in Boca Raton that housed the offices of the supermarket tabloid *National Enquirer*. Ernesto Blanco, seventy-three, who worked in the mailroom, was exposed to the deadly powder that was delivered in the mail. While he survived, he was hospitalized for more than three weeks. *Sun* photographer Robert Stevens wasn't so fortunate; he died of anthrax inhalation.

Mike Irish was editor-in-chief of the *Sun* at the time of the deadly attack. He remembered:

> *My workstation was just two desks away from Bob Stevens, who tragically died from inhalation of anthrax. By total coincidence, my wife Gloria, a Realtor, rented an apartment*

to two of the 9/11 terrorists and as a result was called as a witness for the FBI in the sentencing phase of the recent Mosawi trial in DC. I mention this because our contact with the FBI since the anthrax attack interestingly suggests they believe delivery of the toxin was via multiple letters addressed to various AMI departments since contamination was found in hundreds of locations throughout the building. The government evidently also believes that it was probably Al Qaeda inspired—if only because their other attacks were directed at organizations with national significance to their titles (American Airlines, NBC, et al).

Clearly, this was a scary time. But we hardly had time to worry since we were sent out to temporary locations as far as Miami and New York where for months we succeeded in bringing out multiple weekly magazines without ever missing a deadline.

AMI moved out of the contaminated building that was sealed until the summer of 2004 when the structure was decontaminated of anthrax spores using chlorine dioxide gas. Cleanup of the 65,000-square-foot complex was followed by thousands of tests to ensure the safety of the building before the quarantine was lifted. The building was sold to David Rustine who eventually leased it to Bio-ONE, a company established by former New York City Mayor Rudolph Giuliani. Cleanup costs were estimated at $5 million.

The perpetrator of the deadly anthrax letters still remains at large.

Ten

GOODBYE PAST, HELLO PRESENT

And so, we bid a fond adieu to Boca Raton's amazing past. But as we do, may we recognize that it also has an amazing present. It is the blending of both that gives the city such a rich heritage, one that should be preserved and celebrated as the legacy is passed to the next generation.

BOCA RATON
FACTS AND FIGURES

The following are based on 2004 figures.

Incorporation: May 25, 1925 (Official City Recognition)

Population: Approximately 83,960 within city limits
Approximately 125,000 in unincorporated Boca Raton

Total area: 27.14 square miles within the city limits. Slightly over five miles at widest point. Approximately 77 square miles, including Greater Boca Raton unincorporated area.

Average annual temperature: 74.7 degrees; low, 66.6 degrees; high, 82.9 degrees

Average annual rainfall: 60.75 inches

Average household income: $92,283

Median age: 47

Household size: 2.3 persons

The City of Boca Raton's Population History

Year	Population	Year	Population	Year	Population
1895	8	1940	723	1990	61,492
1903	18	1950	992	2000	74,764
1906	30	1960	6,961	2004	83,960
1920	100	1970	28,506		
1930	320	1980	53,343		

BIBLIOGRAPHY

BOOKS

Ashe, David. *Tracks in Time*. Boca Raton: David Ashe, 2000.

Buderi, Robert. *The Invention That Changed the World*. New York: Simon & Schuster, 1996.

Conant, Jennett. *Tuxedo Park: a Wall Street Tycoon and the Secret Palace of Science that Changed the Course of World War II*. New York: Simon & Schuster, 2002.

Curl, Donald W., and John P. Johnson. *Boca Raton: A Pictorial History*. Virginia Beach, VA: The Donning Company, 1990.

———. *Palm Beach County*. Northridge, CA: Windsor Publications, 1986.

Evans, Arthur S., and David Lee. *Pearl City, Florida: A Black Community Remembers*. Boca Raton: Florida Atlantic University Press, 1990.

Kleinberg, Eliot. *War in Paradise: Stories of World War II in Florida*. Cocoa: Florida Historical Society Press, 1999.

Ling, Sally. *Small Town, Big Secrets: Inside the Boca Raton Army Air Field during World War II*. Charleston, SC: The History Press, 2005.

Shrady, Theodore, with Arthur M. Waldrop. *Orange Blossom Special: Florida's Distinguished Winter Train*. Bay Pines, FL: Atlantic Coastline and Seaboard Air Line Railroads Historical Society, Inc., 1996

Thuma, Cynthia. *Boca Raton*. Charleston, SC: Arcadia Publishing, 2003.

Waldeck, Jackie Ashton. *Boca Raton: A Romance of the Past*. Boca Raton: The Bicentennial Committee of Boca Raton, 1981.

NEWSPAPERS AND PERIODICALS

The following are available at the Boca Raton Historical Society.

Austin, Daniel F., and David M. McJunkin. "The Legends of Boca Ratones." *Spanish River Papers*, May 1981.

Benedetto, Diane. "Childhood Memories." *Spanish River Papers*, October 1975.

———. "The Early Days." *Spanish River Papers*.

Bibliography

"Boca Raton's First Church." *Spanish River Papers*, May 1978.

Brown, Drollene. "World War II in Boca Raton: The Home Front." *Spanish River Papers*, Fall 1985.

"City, Warren to Request More Intracoastal Bridges." *Boca Raton News*, February 20, 1966.

Cohen, Douglas. "Who Killed Leno and Louise Lazzari?" *Palm Beach Post*, January 19, 1992.

"Council Holds Regular Meeting." *The Pelican*, August 10, 1951.

"Early Days of the Boca Raton Fire and Police Department." *Spanish River Papers*, May 1977.

"Eighty One Years Founder's Day Observance, 1918–1999." Ebenezer Missionary Baptist Church, 1999.

Faris, Dawn. "Boca Pair watched Rich Play in '30s." *Miami Herald*, June 25, 1984.

"Federal Aid Highway for Boca Raton." *Boca Raton Record*, February 1, 1917.

"Frank H. Chesebro, 1850–1936. His Florida Years: Part One, 1889–1925." *Spanish River Papers*, February 1975.

Fryzel, Louis. "Wooden Bridges & Iron Men." *Fiesta*, January 1971.

Gates, Harley D.. "History of Boca Raton." *Spanish River Papers*, May 1973.

"Hildegarde F. Schine." *Spanish River Papers*, May 1976.

Kearney, Bob. "Mostly Sunny Days." *Miami Herald*, 1986.

Kelly, Dick. "Joe College to Take Place of G.I. Joe." *Fort Lauderdale News*, June 19, 1961.

King, Dale. "Dixie Highway was first 'interstate' for South Florida." *Boca Raton–Delray Beach News*, October 9, 2005.

———. "Fore." *Boca Raton–Delray Beach News*, May 29, 2005.

———. "Gentlemen, start your engines." *Boca Raton–Delray Beach News*, May 22, 2005.

Kleinberg, Eliot. "Military Refuses to Detail Cold War Testing in Boca Raton." *Palm Beach Post*, June 21, 2003.

———. "Veteran Recalls Secret Weapon Work at Boca Airfield." *Palm Beach Post*, July 7, 2002.

Knott, James R. "Roads, Beaches and Bootleggers." *Palm Beach Post Times* and *Palm Beach Daily News*, May 27, 1979.

Laine, Peter. "Boca Raton—City Without Much Beach." *Miami Herald*, October 10, 1960.

"Library Board Says it Shunned Meeting with Art Guild Because of Legal Dispute." *Boca Raton News*, October 29, 1959.

Ling, Sally. *The Legend*. Publication of the Boca West Club, March 1977.

McClare, Kate. "Boca has a new song, rat to promote city festival." *Boca Raton News*, March 29, 1989.

Meyer, Meghan. "Tom Wright founded Tom's Place in Boca." *Palm Beach Post*, February 18, 2006.

Murphy, Janet. *Spanish River Papers*, October 2002.

"'NEWS' History of Boca Businesses Tells of City Changes and Growth." *Delray Beach News*, August 13, 1953.

"Parks and Recreation Facilities." *The Recreator*, Fall 2005.

Pinquinto, David. "Boca Raton City Government." Boca Raton Middle School Research, 2006.

"Police Chief Hugh Brown." *Boca Raton Photo Case*, May 5, 1966.

Raveson, Betty. "South Florida's Sunshine Attracts Chilled Friends." *Palm Beach Daily News*, November 17, 1967.

"Roberta Knapp MacSpadden." *Spanish River Papers*, May 1976.

Sheffield, Skip. "Last Philharmonic Concert." *Boca Raton–Delray Beach News*, May 10, 2003.

————. "Memories and Music." *Boca Raton–Delray Beach News*, February 25, 2002.

Shuff, John, Gregg Fales and David Kohn. "Summary of the 20 Top Companies." *Boca Raton Magazine*, Fall 1983.

"Singing Pines." *Spanish River Papers*, October 1979.

"A Special Column Item." *Spanish River Papers*, Fall 1982.

"Students Spark 'Celebration March.'" *Boca Raton News*, March 18, 1965.

Tiernan, Carolyn. "Shop the Old World Way Royal Palm Plaza, Boca Raton." *Fiesta*, October 1975.

"Then & Now." *Boca /Delray Jewish Times*, August 29, 1997.

Waldeck, Jacqueline. "How Boca Helped Win the War." *Boca Raton Magazine*, March–April 1982.

"W.F.L.A. Goes on the Air." *Boca Raton Record*, March 1, 1927.

Wylie, Philip, and Laurence Schwab. "The Battle of Florida." *Saturday Evening Post*. March 11, 1944.

E-MAIL CORRESPONDENCE

Boomhower, Ray. Correspondence with author, 2004.

Carannante, Sharma. Correspondence with author, June 6, 2006.

Hagedorn, Dan. Correspondence with author, 2004.

Hunter, Millicent. Correspondence with author, April 3, 2006.

Rice, Carol. Correspondence with author, June 7, 2006.

Sterling, Bruce. Correspondence with author, May 6, 2006.

ORAL AND WRITTEN HISTORIES

Barrett, Peter

Bell, Martha Barrett

Benedetto, Diane

Black, Joyce

Brenk, Shirley Rose

Brown, Joyce

Carswell, Archie

Bibliography

Carswell, Irene
Chavez, Manny
Cochrane, John H.
Cornwell, Marion
Davey, Robert
Douglas, Carl
Douglas, Carolyn
Durham, Eldra
Gehris, George
Grossman, Armand
Harr, Trude W.
Irish, Mike
Jackson, Amos
Jackson, T.J.
Jakubek, Pat
Jenkins, Mary Lee
Kobayashi, Tom
Lamb, Bill
Mangrum, John
Martin, Lois
Mikunda, Louis
Owens, Arlene
Pitts, Jack
Robbins, Lenore
Sheppard, Allan
Slone, Bob
Spain, George
Troxell, Jeanette Akins
Vaughtner, Jim
Walbridge, Haydee
Wallish, Ed
Williams, Louise

DOCUMENTS AND MICROFILM

The Harid Conservatory, April 3, 2006.

History of the BRAAF 351st AAF Base Unit Boca Raton Radar School. Available at the Boca Raton Historical Society. Roll numbers B2053, B2054, B2055 , B2056, B2057, 2058, 1942–47.

History of Royal Palm Polo in Boca Raton. Royal Palm Polo, 2006.

Park and Recreational Services. Boca Raton Development Services, 1965.

Bibliography

Patterson, Dorothy W. *Yamato/New Town Project*. Delray Beach, FL: EPOCH Historical Organization, 2003.

A Study of Recreation and Park Areas and Facilities. National Recreation and Park Association, April 1965.

This is Our Story. The Debbie-Rand Memorial Service League, Inc., 2003.

INDEX

Index

Index

Y

Please visit us at
www.historypress.net